DISASTERS OF OHIO'S LAKE ERIE ISLANDS

WENDY KOILE

THE
History
PRESS

Published by The History Press
Charleston, SC 29403
www.historypress.net

First published 2015

Manufactured in the United States

ISBN 978.1.62619.819.7

Library of Congress Control Number: 2015936219

To my mother: there for me through every joy and every near disaster I find myself in occasionally.

Contents

Acknowledgements

First, I would like to thank my commissioning editor, Krista Slavicek, at The History Press. Your encouragement and expertise have been invaluable to me. I would also like to thank the rest of the team at THP for turning my words into a product that I am proud to share with the world.

Thank you to the many librarians, genealogists and museum coordinators who helped me with my research, including Jennifer Fording at the Harris-Elmore Library, the research department of Sandusky Library, the librarians at Ida Rupp Library, Peggy Debien at Ottawa County Historical Museum and Richard Norgard for sharing his impressive research. I would also like to thank island locals Jack Wade and Leslie Korenko for answering my questions. A special thanks to Michael Gora for sharing his extensive knowledge of the islands.

Likewise, thanks to Tim Dehring, Dominique King and Larry Lawson for images of our favorite islands.

Special thanks to my best writing friend, Jane Turzillo, who always offers me support, laughter and great memories.

Thanks to my Zane State family and students for sharing in my success.

Thanks to Andy and Emma Koile for quietly waiting for me to write my book. Your patience and understanding mean so much to me.

Thanks to my other family members and close friends who have always been there for me. I love you all!

Introduction

To the imagination there is something attractive in the very name of island. It is the island, the island, that fills the boyish heart with wondering interest.
—*William W. William*

NEAR DISASTER

On a warm sunny morning in June 1920, four children set sail across the wide blue inland sea. Virginia, twelve; Mervin, nine; Richard, six; and Robert, three, were not only in search of an adventure, but apparently there was a treasure to be found as well. As the carefree children pushed off from the Michigan beach into Lake Erie, they were convinced they would land on one of the many "treasure islands" of the lake.

Unfortunately for the children, the island never appeared. After nearly an hour, the dream of finding such a place was dead in the water. Worse still, the treasure seekers did not know how to get back to shore. Over the next panic-stricken twenty-seven hours, the youngest two managed to fall overboard, while the older children jumped in to save them. Mervin decided to tie his little brother to his seat to prevent further trouble. As the sun sank into the horizon, the children huddled together in the darkness, afraid and alone. This was not how they had pictured their island adventure.

The next afternoon, the captain of the steamer *The City of Toledo* noticed an unusual scene: four children set adrift in a rowboat in the middle of Lake Erie. Pulling them onboard, he realized that they were lost, scared and quite sunburned. Richard proudly produced two small fish from his trousers to feed his pet turtle at home. Other than a broken dream of finding Treasure Island, the children had survived a near disaster.

Not unlike the children on their expedition, visitors have sought a great adventure when traveling to the Lake Erie Ohio islands. And most of the time, a one-of-a-kind, fun-filled vacation is found while visiting the most beautiful destinations in Ohio. Yet occasionally, as with the four children, a problem may arise that could ultimately lead to an emergency situation when attempting an island adventure.

Although no one can deny the unique beauty of the Lake Erie islands, stories of hardships, struggles and disasters have always been a part of their history. The very concept that captivates many island locals as well as tourists is sometimes the very idea that leads to extreme situations; the isolated environment of island living comes with both blessings and, so it seems, curses.

SETTLEMENT

Surprisingly, the islands and land along the lakeshore were purchased last during Western Reserve settlements in the late 1700s. Most early pioneers were farmers, and the land inland of the reserve was perfect for such a trade. Besides, the storms and wind off Lake Erie were notorious for decimating anything in their path. Similarly, the islands were considered part of the Western Reserve package, yet why would early settlers choose these areas made of limestone and heavy forests? Not only that, but the islands were entirely exposed to whatever element the lake chose to throw their way.

By the early 1800s, most of the land in the Western Reserve had been purchased by land companies. The islands and areas in proximity to the shore were considered undesirable to early Ohioans. When Ohio was adopted for statehood in 1803, the islands were void of human activity minus an occasional hermit, overnight fisherman or Native American hunting tribe.

To add to the already lacking curb appeal, in 1812–13, the battles for Lake Erie raged on the open waters near the islands. As the American and British navies battled it out, early settlers stayed as far from the action as possible.

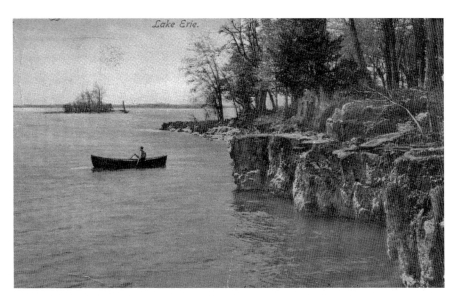

The rocky shoreline of Put-in-Bay, South Bass Island. *Courtesy of the Ottawa Historical Museum.*

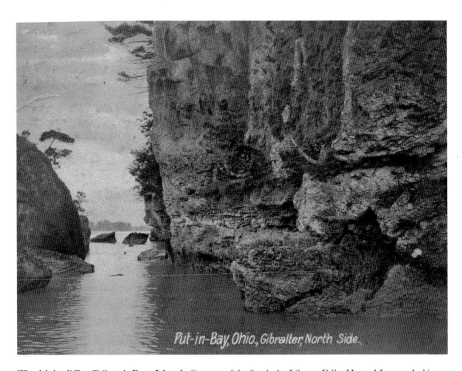

The high cliffs off South Bass Island. *Courtesy of the Sandusky Library Follet House Museum Archives.*

Finally, off Put-in-Bay in September 1813, the last blast was sounded as Commodore Perry and his fleet took control of the lake for the Americans once and for all.

With official statehood, a reputation for good harvesting grounds and finally some peace and quiet, Ohio saw a great influx of settlers wishing to become full-time citizens. As the townships filled with young families, new ways of life cropped up as well, including iron milling, coal mining and the manufacturing of modern farming implements. By the 1840s, Ohio was a bustling industrious state—a leader in the United States.

The new industry as well as some faithful standbys brought more attention to the islands. For one, the industrial tycoons of the Great Lake regions realized they could easily ship their products across the lakes. With this idea came a substantial boom in shipping companies, harbor towns and railroad expansion to the shores of the lake. In the middle of the flow of so much wealth sat the uninhabited land parcels on the shores and islands of the lakes. Now, Ohioans were able to make a successful living by tapping into a natural resource stretching out across the expansive northern horizon. Buyers were ready to buy, and lakefront property was available.

Another natural industry that continued to grow was beneath the surface of the waters. Fish, by the net full, were plentiful. Theresa Thorndale, an early island historian, writes, "It is in fact generally conceded that the Lake Erie archipelago with its extended network of channels, together with the bays and inlets of adjacent inland shores, formed in past years the most

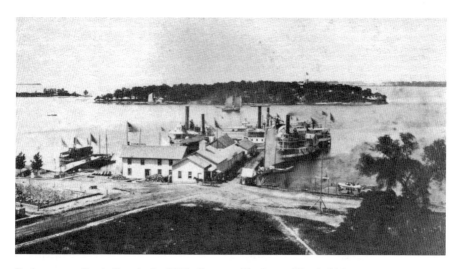

Early scene at Put-in-Bay docks, 1872. *Courtesy of the Ottawa Historical Museum.*

Right: A mini souvenir booklet showcasing island attractions of 1886. *Courtesy of the Ottawa Historical Museum.*

Below: The steamer *Put-in-Bay*, 1834, one of many steamers built to transport passengers. *Courtesy of the Ottawa Historical Museum.*

extensive fresh water fishing in the world." Fishermen by the boatload began to appear in newly forming villages along the lake and on the islands.

Lastly, on the islands—in particular Kelley's Island—layer upon layer of limestone was discovered. Huge quarries were established, and able-bodied men were needed to mine and transport the slabs to the various harbors and lime-burning companies. Hardworking men lined up for these paying jobs on the islands, bringing their families and belongings to settle near their place of employment.

Meanwhile, Ohioans continued to work in the sweltering factories in the cities or toil away in the heart of farming fields along the rural county lanes. The day-to-day work was endless in young America, so when a day off did occur, hardworking folks enjoyed it to the full extent. Days spent on a shimmering blue lake proved to be a relaxing and restful getaway.

As early as 1818, steamboat passenger ships carried sightseers and travelers around the Great Lakes. On Lake Erie, the first steamer, called *Walk in the Water*, made numerous trips to Detroit. When other cities realized the potential revenue these ships could bring, they quickly followed suit. It was from the decks of these steamers that perhaps inland citizens first gazed upon the intriguing Lake Erie islands.

By 1838, Sandusky, which overlooks the islands, had become one of the most prominent ports and shipyards on Lake Erie. With boat traffic coming and going constantly from Sandusky Bay, it became easy to escape to the nearby islands by hopping on one of hundreds of boats that traveled through the area. Fishing, camping and exploring tempted the first island vacationers to the area. By the mid-1800s, inns and hotels had been constructed on the islands to cater to the new crowds. Steamers appeared for the sole purpose of transporting visitors to the islands. The emergence of a world-famous amusement park took shape on Sandusky Bay. Accordingly, the concept of Ohio's Vacationland was born on the shores and islands of western Lake Erie.

THE OHIO ISLANDS

Of the twenty-one islands still remaining in Lake Erie, fifteen sit in Ohio waters. Harlan Hatcher writes in an early history book entitled *Lake Erie*, "They rise up out of the water like huge green steppingstones for some legendary Indian god to stride over from one hunting and fishing ground to

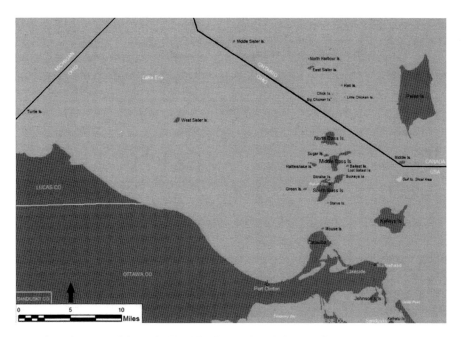

A modern-day map of the Lake Erie island area. *From Wikimedia Commons.*

another." Some are bustling villages while others are laidback retreats, and some are void of human life altogether. Regardless, the fact that they are islands cut off from mainland conveniences draws the hearts and curiosities of Lake Erie tourists. For over a century and a half, hundreds of thousands have flocked to the islands in search of peace and tranquility. More times than not, that is exactly what they found. But sometimes on those detached islands, problems that are small in nature on the mainland could quickly and terrifyingly become disasters of Ohio's Lake Erie Islands.

OHIO'S ISLANDS

Ballast Island
Buckeye Island
Gibraltar Island
Johnson's Island
Kelley's Island
Lost Ballast Island

Middle Bass Island
Mouse Island
North Bass Island
Rattlesnake Island
South Bass Island (Put-in-Bay)
Starve Island
Sugar Island
Turtle Island
West Sister Island

Ohio's Lake Erie Peninsulas

Catawba Island
Cedar Point
Marblehead/Lakeside

Lost Islands

Gull Island
Kafralu Island

Chapter 1

Green Island

Fire and Ice

The oldest and strongest emotion of mankind is fear, and the oldest and strongest kind of fear is fear of the unknown.
—H.P. Lovecraft

PUT-IN-BAY

The air swirled with the magic of New Year's Eve. A grand party was in full swing on the South Bass Island at Put-in-Bay. Youngsters twirled and laughed into the night at Doller's Hall, one of the loveliest dance halls of the island. The weather had been unseasonably warm, a mild sixty degrees, for most of New Year's Eve day in 1863.

One guest, Pit Drake, was especially excited to attend the party. As the son of the Green Island light keeper for the past nine years, it was a rare occurrence for the twenty-three-year-old young man to escape the isolated island, let alone attend such a fine party in the heart of the winter season. The night was full of friends, laughter and promise.

However, as the partygoers played in the warm glow of lights and happiness, a dark storm front was quickly moving over the lake. Soon, a gale-force wind howled into the pitch darkness of the open waters. In a matter of hours, the temperature had tumbled from sixty degrees to twenty-five below, setting a new low record for New Year's Eve in Ohio.

Doller's Landing, 1913. *Courtesy of the Sandusky Library Follett House Museum Archives.*

The guests soon felt the icy air creeping into the dance hall. The lake could be heard over the music with its thrashing about on the shore in the form of enormous waves. Rain pounded the side of the dance hall. The wind, most audible of all, howled over the entire island.

Around 7:00 p.m., while huddled around the stove for warmth, practically yelling to be heard over Mother Nature, the guests were startled to notice an orange glare in the west-facing windows. As the youngsters gathered near the windows, a shaken voice cried out, "Green Island Light is on fire!"

As Pit Drake processed the information, it was as if an electric shock went through him. For an instant, he stood rigid, staring out the window. His family was still on the island; his father had insisted that they keep the light over the holiday. His mother, two sisters and brother-in-law were over there as well. This could not be happening.

Immediately, Pit sprang into action. He had to get to Green Island. He had to get to his family. As Pit broke free from the crowd at the windows, the other guests realized his intentions. Young men grabbed for Pit in attempts to stop him. However, he was quick and determined, and he smoothly made it out of the hall.

A few yards from the exit, Pit quickly found his tiny rowboat bouncing around in its moorings at Doller's Dock. But as he reached for the line to pull

the vessel inward, he was accosted from behind. The young men of the party held the struggling and panicked young man against their strength. There was no way Pit could cross the lake in this storm. He would surely meet his death in the raging sea. With no other option, Pit stood sobbing into the night, watching the orange blaze in the night grow larger.

By daybreak on New Year's Day, the gale had blown itself out. The channel between Put-in-Bay and Green Island was near frozen, with solid chunks of ice already in place. Pit and several men set to the task of securing an ice cutter and began the slow two-mile journey over to Green Island. The men bundled against the frigid cold, reminding them that it was January 1 regardless of the early spring temperatures the day before.

With the horrific creaking of the ice, Pit wondered about his family. The fire that had raged through the night had surely destroyed the wooden lighthouse and residence. But did it take his family as well? And even if they survived the fire, how could they have survived the below-freezing temperatures on an exposed island?

As the recue party ascended the icy banks of Green Island, they were met with an eerie silence. The former light was now a black pile of ash. The house was completely gone as well. Near the woods, Pit noticed that the outhouse still stood untouched by the flame. Was there a chance? As Pit creaked open the door, his eyes took a minute to adjust to the darkness. What he found therein was unimaginable.

GREEN ISLAND

Green Island, just a skip across the pond from Put-in-Bay, sat dormant for several years following the War of 1812. As the bigger islands were being harvested for grapes, limestone and tourist attractions, not many settlers had interest in what was then called Moss Island. That is, until a discovery was made there by accident.

After a report of finding strontian crystals on Put-in-Bay, Major Joseph Delafield (of the International Boundary Commission) and Louis De Russy (an American topographer) decided to stop at Green Island after they could not find any more crystals at Put-in-Bay. To their delight, Green Island, especially in the cliffs, was heaping with the mineral. By the late 1820s, the island was the main source of the mineral, which was used to produce sugar from sugar beets. The supply was exhausted by 1898.

As the Bass Islands became more congested with traffic, a need for a lighthouse on the small island emerged. In 1855, the first Green Island Lighthouse was finished. According to Lighthousefriends.com, "Built of brick, the lighthouse consisted of a cylindrical tower with a diameter of six feet, three inches that was attached to one end of a one-and-a-half-story keeper's dwelling. The tower was topped by an octagonal lantern room from which a fixed white light, varied every 150 seconds by a bright flash, was shown at a focal plane of forty-three feet." Colonel Charles Drake was commissioned the first light keeper.

Charles moved with his family in tow to the deserted island. Although lonely during the winter months, life in a lighthouse was pretty routine, minus a few big storms and an occasional stranded vessel. In the summer, the Drakes, especially the teenage children, made journeys to Put-in-Bay for fellowship. The family seemed quite content with their living arrangements—until an unusually warm New Year's Eve.

Around 6:00 p.m. on that fateful day, Colonel Charles Drake was lured to the dining room by the smell of his wife's home cooking. He had spent the afternoon keeping an eye on the lake, which was unusually busy at this time of year due to the odd break in the weather and the fact that it was New Year's Eve. As darkness fell, Colonel Drake made sure the light was burning hot with oil and made his way down to the adjoining living quarters. Following the scent from the oven, the colonel joined his wife; his oldest daughter and

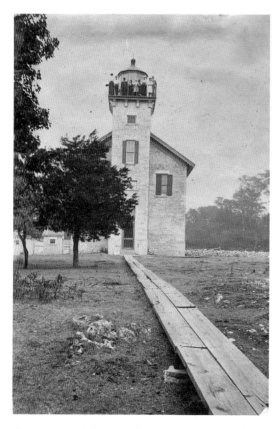

Green Island Lighthouse. *Courtesy of the Rutherford B. Hayes Library—Frohman Collection.*

son-in-law; and his youngest daughter, twelve-year-old Sarah. The only one missing was the middle child, Pit, who had run off to a young people's social gathering at nearby Put-in-Bay.

Over the course of dinner, the colonel recognized the turn in the weather. After all, this was not his first year as keeper, and his mind was trained to hear and see small details when it came to the lake. The wind and rain were now hammering the island and lighthouse. With the wind, a cold front was blowing in and quickly turning the rain to snow. At least his family was safe. And Pit was probably having the time of his life over on the other island. Thus, the colonel set his mind to enjoying the time with his family.

As the Drakes laughed and enjoyed their dinner, a strange noise echoed down from the lighthouse. Sarah, believing it was her curious cat, ran up the stairs to check. Immediately, the family heard Sarah scream from the lighthouse tower. The men rushed to find Sarah, who was frozen in terror. The lighthouse was engulfed in flames and smoke.

Quickly, the colonel ordered all family members out of the house. The wind was working to spread the fire almost as fast as they escaped. The men climbed ladders as the women brought bucket after bucket of water. After nearly three dozen trips to the lake for water, the women were near collapse from exhaustion. Colonel Drake knew in his heart that the lighthouse and home could not be saved even with the bucket brigade.

With his ever-present logic, the father and husband ran back into the burning house, where he was able to grab two small mattresses. With arms and face burnt, he heaved the heavy pallets onto the snow. Meanwhile, Sarah seemed to be in a trance as her hands and feet showed signs of frostbite. With the lake now a crashing and spraying icy monster, and the lighthouse a cylindrical inferno, Colonel Drake looked around helplessly. In that moment, he noticed that the tiny outhouse near the woods still stood.

The family made their way to the building with the mattresses and hot boulders obtained near the fire. Being sure to keep Sarah extra warm, they huddled down, tangled in the mattresses and one another.

The next morning, with the sound of the waves a gentle lapping against the ice chunks now, the family slept in pure exhaustion. Suddenly, the cramped outhouse was flooded with blinding light as the door was pried open. As Pit Drake's eyes adjusted to the darkness, he found his family stirring around with the bright light and cold air entering their refuge. The worst New Year's Eve had turned out to be the most thankful New Year's Day.

In 1864, a new lighthouse was built using limestone as the main building material. Colonel Drake served another five years at the new lighthouse

before retiring. For the next sixty years, various light keepers continued to keep watch over the waters near Green Island and the Bass Islands. In 1926, the government elected to construct an automated light on top of a steel skeletal tower. The remains of the 1864 light are still on the island in a state of disrepair. The limestone lighthouse is on the Lighthouse Digest Doomsday List.

Green Island was purchased by the State of Ohio in 1961 and is currently used as a state wildlife refuge. It is off-limits to the public.

Chapter 2

Johnson's Island

Escaping

Oh who has not heard of that isle in Lake Erie, so guarded today—so unheeded before.
—Lieutenant E.A. Homes

A gentle wind sweeps across the lake, turns inward toward the bay, hangs a wide left and whistles through the gravestones of the tiny iron-fenced cemetery. Less than a mile across the bay, the world-famous Cedar Point coasters, quieted for the winter, pay the tiny cemetery no mind. For the amusement park is a happy place, not to be bogged down in tales of woe. Surrounding the cemetery, several multimillion-dollar mansions huddle together as if to protect themselves against the lonely feeling that seems to lurk about the area. Under the canopy of trees, an atmosphere of heartbreak, loneliness and desperation can still be felt while visiting Johnson's Island Cemetery.

The island was never intended for a prison. When Epaproditus Bull from Connecticut purchased the small island off the Marblehead Peninsula in 1809, his main goal was to quarry for limestone. Unfortunately for Bull and his family, they were not able to establish a mine on the newly named Bull Island. Native Americans of the area were not happy with the white settlers, and they made this known, especially when it came to one of their favorite island hunting grounds. After the Indians destroyed the family's cabin on Bull Island in 1812, the Bulls returned to the mainland. Shortly after, Epaproditus died of illness, leaving the property ownership to his descendants.

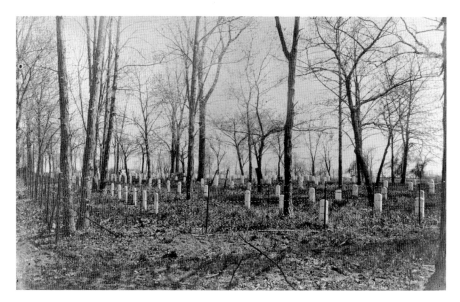

Johnson's Island Cemetery. *Courtesy of the Sandusky Library Follett House Museum Archives.*

In 1852, Leonard Johnson purchased and renamed the island. Once the papers were signed, Leonard began clearing the trees in hopes of eventually turning the island into a three-hundred-acre farm. Before he was able to farm the entire island, Leonard was asked to lease the cleared forty acres to the United States Army. The army wished to use the isolated property as a prison camp for Confederate soldiers. For the next four years, more than nine thousand soldiers would be rotated through the island prison.

The camp was made up of twelve prisons blocks, with one building serving as a hospital. The camp also included a sutler's stand where prisoners could buy items from a civilian running the tent. There were also latrines, a pest house and two large mess halls. Each barrack could hold up to 250 prisoners. A fourteen-foot wooden stockade with raised platforms for prison guards surrounded the camp. The Union army's quarters were outside the wall, along with the magazine building. The island, then without a bridge linking it to the mainland, provided protection from escape attempts—or so the Yankees thought.

Like any prison system throughout history, daring escapes were par for the course. One such tale is that of Captain Benjamin L. Farinholt, a Confederate officer captured during the Battle of Gettysburg. The intention of the Union army was to keep the captain for ten months. This was not the intention of the clever captain.

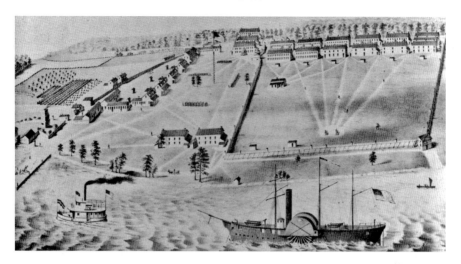

An illustration of Johnson's Island as a POW camp. *Courtesy of the Sandusky Library Follett House Museum Archives.*

An abandoned building years after the prisoner camp era. *Courtesy of the Sandusky Library Follett House Museum Archives.*

On February 22, 1861, the Union guards were preparing for a celebration in light of Washington's birthday. The bay at this time of year was completely frozen, and many of the guards were skating around on the smooth ice. Meanwhile, Benjamin quickly changed into a makeshift Yankee uniform

custom designed by a tailor in the prison. Once in his Yankee gear, Benjamin skated out on the ice, laughing and joking with his new comrades. With each circle around the ice made, Benjamin would make a larger arc in the direction of Sandusky. By the time the heads called for the guards to return to their stations, Benjamin was already in the local travel lanes. When he reached the shore, he was met by a Union sentinel who checked all pedestrians coming and going from Johnson's Island.

Without a moment's hesitation, Benjamin greeted the grumpy-looking guard and thoughtfully inquired of his well-being. The guard, who had stood for hours without any form of camaraderie, complained to Benjamin that his replacement was late. Benjamin sympathized with the sentinel over the pitfalls of being a Union soldier and then went on his way. A few weeks later, Captain Benjamin Farinholt appeared in Richmond and continued on as a successful Confederate fighter during the remainder of the war.

Another attempt to escape did not go so well. Apparently, a tunneling operation was established in one of the cookhouses. A plank had been removed, and a tunnel large enough to fit a man was dug from the building to the prison yard. From the discovered tunnel, the guards pulled three homemade ladders, three knives and three life preservers. The *Cleveland Leader* reported:

> *The preparations for escape seemed to have been systematically conducted and nearly completed, though it is not known as yet exactly what the intentions of the plotters were, when the attempt to escape was to be made, or the number who were concerned in it. The scheme was discovered through one of the prisoners, who happened to be in the hospital, and who hinted that something of the kind was going on. This led to watchfulness and search, which resulted in the discovery of the plot. We understand that the discovery caused great excitement. The roll of prisoners was called, and it was found that none were missing. The excitement continued during the day, and many visited the spot and examined the hole.*

Rumors about the planned escape suggested that the snitch was accosted by a group of men and threatened with hanging. The tunnel experts were never caught.

Although stories of escape are often told in amusement, many miserable days were spent on Johnson's Island. Cold winters, loneliness and homesickness plagued the camp, as often attested to in letters home to loved ones. As Colonel B.H. Jones wrote in a letter home, "Musing lonely, sadly musing is my island prison drear." Another prisoner, upon the closing of the

island prison, wrote, "I leave thy shore, Oh hated isle, where misery marked my days."

Writing one's feeling in letters, poems and journals was another way of escaping among the POWs at Johnson's Island. When the supply boat docked, most soldiers were sure to purchase paper and pen along with tobacco and other necessities.

One less-known Johnson's Island writing came to a beautiful Southern belle named Virginia at her home in Georgia. Virginia had said goodbye to her fiancé near the onset of the Civil War. Her sweetheart had gone off to fight for the Southern cause, and his dedication soon earned him the rank of an officer. Eventually, she received a letter from her soldier that he had been captured and imprisoned at Johnson's Island.

Apparently, for a time the two sent love letters back and forth, with Virginia always signing, "Your own devoted and faithful Virginia." After some time, the letters from Virginia to Johnson's Island became few and far between. Sadly, the soldier died in captivity while awaiting word from his Southern belle in Savanah. Shortly before his death, he told his dear friend at the camp that should a letter come after he died, he would like for it to be placed with his body in his grave.

A few hours after the man's death, the awaited letter came in the afternoon mail. The man's grief-stricken best friend, Colonel Hawkins, slowly opened what he thought was to be the last love letter between the two sweethearts. As he read Virginia's words to her fiancé, a burning rage against the woman set deep within Hawkins's soul.

The letter boldly boasted of the many balls and social dinners Virginia had been enjoying while her betrothed lay sick and desperately awaiting her messages. The letter then took an unforgivable turn as Virginia gushed on and on about the most handsome colonel in General Wheeler's army. She did not attempt to conceal her growing interest in the officer stationed near her home. The final blow came in her closing line of this heartbreaking letter. For instead of the "devoted and faithful" signature line, this letter signed off "Respectfully, etc. Virginia."

As Colonel Hawkins suffered through his grief, his anger toward Virginia grew. Finally, he was able to express his deep-rooted feelings through a poem, which he mailed to the young woman. The poem, ten stanzas long, chastised the woman for her selfish and coldhearted behavior. The poem described how his deceased friend had waited in misery for her letters. He explained that the letters were like sunlight to her fiancé. He then suggested that the woman was vain and a game player. The last three stanzas contained perhaps the harshest words to the receiver:

Tonight the cold wind whistles by,
As I may vigil keep,
Within the prison dead-house,
Where few mourners come to weep.
A rude plank coffin holds his form,
Yet death exalts his face,
And I would rather see him thus
Than clasped in your embrace.

Tonight your home may shine with lights
And ring with merry song,
And you be smiling as your soul
Had done no deadly wrong.
Your hand so fair that none would think
It penned these words of pain;
Your skin so white—would God, your heart
Were half as free from stain.

I'd rather be my comrade dead
Than you in life supreme:
For yours the sinner's walking dread,
And his the martyr's dream.
Whom serve we in this life, we serve
In which is to come:
He chose his way, you yours; let God
Pronounce the fitting doom.

The poem and story appeared in a romantic interest magazine, *Heart Throbs*, in 1905.

In 1865, at the close of the Civil War, all POWs were released. In 1866, the barracks were auctioned off by the United States government. The few remaining blocks eventually fell into disrepair. For those who had died while at Johnson's Island, small wooden markers were placed in the cemetery near the shore. Full ownership of the island was given back to Leonard Johnson and his family. In 1889, a group of sightseers and newspapermen raised awareness concerning the dilapidated state of the markers after visiting the cemetery. A group in Georgia then began to raise funds to replace the wooden markers with marble ones. Many railroad owners offered to haul the heavy stones to Ohio, and Leonard Johnson

transported the cargo to his island free of charge. The island continued to be used for farming until 1894.

During the late 1890s, the Lake Erie islands were well underway as famous vacation sites. The new owners of Johnson's Island decided that they were not to be left out of the trend. In 1894, a new hotel and resort area sprouted up on the island known as Johnson's Island Pleasure Resort. For a time, the resort was well received. A few years in, a fatal accident occurred when a trapeze artist was accidentally shot. This, in turn, led to a lawsuit by the family. In that same year, the large dance pavilion also burned down. After just eight years in operation, the resort closed. In 1904, a second attempt to establish a resort island was made. This was a much shorter run, and the resort went out of business in 1908.

In 1910, a bronze statue was shipped to the island and placed near the cemetery. Veterans from the North and the South, along with their families, attended the dedication. Hundreds showed up to honor the men who had spent their last days in the prison camp. The ferries were kept extremely busy transporting visitors throughout the day.

Form 1902 to 1916, the island was quarried for limestone and became a small village for the working families. After the lime had been depleted, the

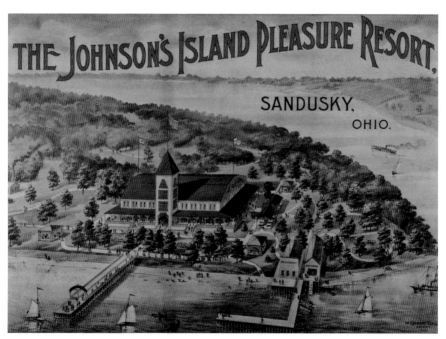

Johnson's Island Pleasure Resort postcard. *Courtesy of the Sandusky Library Follett House Museum Archives.*

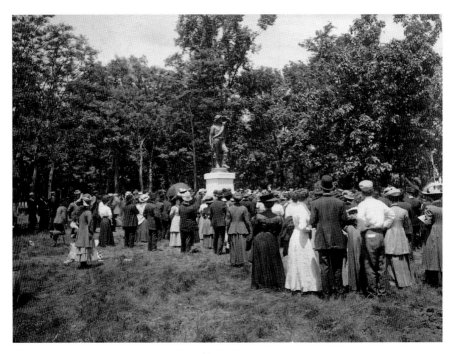

Johnson's Island monument dedication and memorial. *Courtesy of the Sandusky Library Follett House Museum Archives.*

island, so rich in history, sat abandoned and unattended for the next forty years, only occasionally being used for coast guard training.

In 1956, plans were laid for the construction of several vacation homes on the island. The homes were so beautiful and the island so peaceful that the wealthy purchased the homes not as rentals but as permanent homes. By 1965, construction of a causeway to the island was scheduled. Some of the mining equipment from the limestone days was used to begin construction. It was slow going, and by 1977, the homeowners association paid to have the causeway finished. Housing development continued throughout the years.

In 1990, the island was designated a National Historic Landmark as locals and historians sought to keep their piece of Civil War history.

Today, visitors are welcome to visit the cemetery. With its lush greenery, the joyful sounds of Cedar Point nearby and stunning views of the lake, it is easy to forget that the area was once a place of much misery. Yet even above the beauty, the island still whispers its song of sadness for those willing to listen.

Chapter 3
Turtle Island

Endangered Life

Life at its best and finest and at its worst and most tragic is represented in the skeleton of the once fine lighthouse of Turtle Island.
—Toledo Blade, *1929*

The tiny dot on two separate state maps is nearly invisible in the large blue shaded area representing Lake Erie. A dashed line slices through the center of the small dot, signifying the boundary between Michigan and Ohio in the open waters. However, the dot, no matter how tiny, how divided, strongly protests the presence of anyone or anything upon it, whether Buckeye or Wolverine originated.

Turtle Island, which can be seen from Maumee Bay, is different than all the other islands when considering its geological makeup. Most likely, the island was once part of the Little Cedar Point Peninsula, which juts out into the water at a northwest angle. Over time, the lake water covered most of the peninsula, separating the most northern point, and formed a six-and-a-half-acre island. This island, not formed by the glaciers as the big islands are, is primarily made of sand and gravel. This geographical feature in itself would eventually contribute to the island's demise. It seems as though luck was never on the side of Turtle Island, even with $1 million invested that was meant to save it.

In its earliest history, the natives of the area frequented the island in order to gather seagull eggs—a grocery staple for anyone living near the lakeshore at the time. At one time, arrowheads could be found on the land, evidencing the

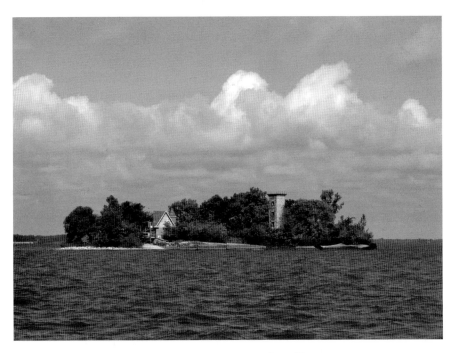

Turtle Island as it appears today. *Courtesy of Dominique King, midwestguest.com.*

hunting expeditions. The Native American influence continued over the land when the island was named Turtle Island after a Native American who fought for peace and justice between the natives and early pioneers. Chief Little Turtle earned a Silver Peace Medal commissioned by George Washington in the late 1700s, and the island was named for the respected human rights leader.

So far, so good on the tiny little island. However, the tides turned dramatically for the fate of anyone or anything placed on the island near the turn of the eighteenth century.

The story of mishaps for Turtle Island began in the 1790s in the heat of the Northwest Indian War. In attempts to stop Mad Anthony Wayne and his victorious army, the British commissioned a fort built on Turtle Island. The log building was made of sturdy timber, and gunboats of sorts were positioned around the island. However, Mad Anthony, riding high on his victory of the Battle of Fallen Timbers of 1794, simply pummeled the island fort. The remaining British hopped aboard the first boat out of there, abandoning the fort once and for all.

Once the fighting ceased, land in the Northwest Territory began selling at a rapid rate. However, a small island stuck in a stormy great lake with a

rotting wood fort was not prime real estate. Thus, in 1827, the United States auctioned the parcel to a Michigan resident. The property size was listed as 6.68 acres in the deed.

As business boomed along the lake and a fancy structure known as the Welland Canal was constructed between Lake Ontario and Lake Erie, shipping traffic was on the upswing. To travel to and from Toledo Harbor, a major shipping hub in Lake Erie, sailors had to be on the lookout for barriers. Alas, a six-acre island in the dark could most definitely be a stumbling block. Therefore, after several wrecked ships, the government deemed a lighthouse here a must-have.

In 1831, the United States bought back the island for $300 in anticipation of the lighthouse being constructed. Congress appropriated $5,000 for the construction of a lighthouse and $2,000 to address erosion issues. In 1832, the first light of Turtle Island was lit, casting its beam up to six miles away. In 1866, after a mere thirty-four years, the original lighthouse had deteriorated drastically. A new light with the addition of a light keeper's house was commissioned to be built. The new light tower stood forty-four feet tall with an attached one-and-a-half-story keeper's house. The history books boast that a ship never went down in the seventy-two years that the lighthouse operated. However, those who attempted to inhabit or build on the land itself were not so lucky.

The first light keeper, Samuel Choate, died on the island from cholera in 1834. His son saw to the task of burying his father on the land. Not long after, the son, too, died from the illness. The son's wife and two children were left alone on the island for weeks. Eventually, a sailor noticed the darkened light. He approached the island, found the family there and escorted them to Toledo.

Erosion plagued the tiny piece of land. The soft sand and gravel soil was no match for the storms and waves that rage on Lake Erie. By the late 1830s, most of the island had been swallowed up by the lake, leaving a mere one and a half acres. Oftentimes, light keepers would awake to find waves knocking at the front door of the lighthouse.

In 1854, the tenth light keeper, Okey McCormick, was caught in a furious storm while returning from a supply run in Toledo. Waves pounded his small sailboat until eventually Okey himself was washed overboard to be claimed by the lake.

In another sad turn of events, in 1867, Nathan Wint Edson, the new Turtle Island light keeper, and his wife, Ann, set up shop on the island. Perhaps Nathan learned of this job opening from his father, Nathan Edson

Sr., keeper of the West Sister Island Light. Regardless, the young couple busied themselves with light keeping duties and seeing to the needs of their young son. As the 1869 winter raged, building ice walls on the lake, the couple hunkered down for the vicious season.

One frigid afternoon, the Edsons were startled by a knock at the lighthouse door. This must have been quite frightening considering that the lake was almost frozen and the nearest neighbors were about five miles away. Upon slowly creaking open the nearly frozen door, Nathan found his brother-in-law, Martin Gouldren, standing shivering in the blizzard-like elements. With one look at his face and the fact that he was even on the island this time of year, the couple knew it could only be bad news. Alas, Martin came bearing the news that Nathan's father had passed away at his station on West Sister Island. Martin and Nathan set to the task of journeying to Toledo, five miles away, in order to purchase a coffin for proper burial of their loved one on West Sister Island.

After a few days, the lake provided the narrowest ice-free channel. The brothers-in-law set out to cross the gap between island and land. However, as the men started out on this sad journey, about a mile from Turtle Island, the channel closed up all around them. The boat became wedged in the ice.

It is believed that Ann could see the commotion from the island. With the frigid elements against her, she made several attempts to reach the boat by walking the ice. The journey proved too dangerous, with unfrozen openings and moving ice floes the entire stretch. Both men perished from the disaster. Later, their bodies were found frozen on the ice as if they had attempted to walk back to the island shore.

With this turn of events, three women were left widowed. Nathan's mother and Marvin's wife, both of West Sister Island, were left stranded waiting for word from land. Ann, Nathan's wife, understood her predicament and swiftly made a courageous decision. Astonishingly, Ann wished to stay on the island and continue as the light keeper. After all, she knew quite a bit about this occupation. Therefore, for two years, Ann Edson is recorded as being the eleventh and only female light keeper of Turtle Island.

But the story is not quite complete. In 1870, a sailor by the name of William Burrows was sent as an assistant for Ann. Whether fate or the remote and romantic setting, the light keeper and her assistant became smitten. In 1871, the *Toledo Blade* ran a local news piece entitled "Wedding in a Lighthouse: The Romance of Turtle Island." Although romantic indeed, the bad luck that continually plagued the island made an unsuccessful attempt to wreak havoc that hot July day.

As the wedding guests departed Toledo, the lake was at its calmest. However, once the wedding-goers were near the island in their small boat, a sudden gale whipped across the lake. William, at once, changed from his freshly pressed wedding garb into his work gear. As the rain and waves pummeled the tiny vessel, he was thrown onto the beach several times, scratching and bruising his face and arms. Eventually, he made it to the helpless wedding guests and tugged them to shore.

In the meantime, the wedding cake had toppled over, the food table was in total disarray and the wedding decorations had been ripped to shreds. However, Ann, without thought of her wedding essentials, immediately saw to the task of caring for her drenched guests and battered husband. The wedding proceeded later in the afternoon. Romantically, the groom was quoted as saying, "I have been around the world twice, and met many women, yet I have not loved until I met the woman I will marry today." In spite of the island's best efforts, one happy ending came to be that day. According to the *Toledo Blade*, "All the steamers and tugs in the area celebrated the marriage by a whistling chorus that shunned the gale into nothingness."

Despite its romantic nature, the island continued in its decline. Bills continued to pile up with a $15,000 project to build a concrete wall to stop erosion on the land and lighthouse in 1884. As the channel between the island and mainland became more and more shallow, ships were rerouted to a lane with deeper waters. This new and wider lane eventually led to the construction of the Toledo Crib Light in 1901. Thus, on May 15, 1904, the fifteenth and last light keeper of Turtle Island darkened the lamp forever.

Over the next twenty-nine years, from 1904 to 1933, the island changed hands four times. All the while, vandals continued to destroy what nature had left of the light. In 1933, the Toledo Yacht Club leased the island. The club's hope was to restore the abandoned lighthouse, creating a one-of-a-kind clubhouse. Although a great idea, the project proved too expensive and the island too remote and hard to reach for yachters.

For the next thirty years, the island sat vacant and unnoticed except for vandals, thieves and the occasional explorer. In 1965, a tornado touched down and barreled over the island, destroying the keeper's house and lantern room of the tower and leaving a skeleton of a structure in its wake.

After, it seemed as though the island was all but forgotten. An advertisement ran in the *Cleveland Plain Dealer* in 1983 advertising, "Own your own island for $40,000," which was a rock-bottom price even then. With each new buyer came an eventual seller. No one seemed to be able to capitalize on the unique yet crumbling piece of property.

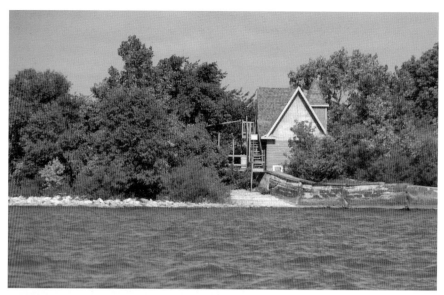

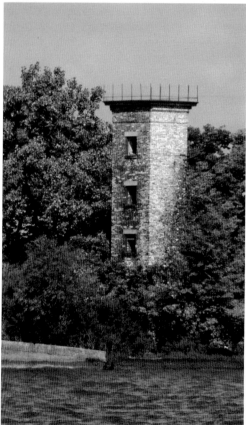

Above: One of the unused vacation rental homes demolished by ice. *Courtesy of Dominique King, midwestguest.com.*

Left: The remains of the Turtle Island Lighthouse. *Courtesy of Dominique King, midwestguest.com.*

In the early 1990s, the Turtle Island Lighthouse Restoration committee formed in an attempt to save a part of history. To this day, the committee is still working to raise enough funds for this massive project. Sadly, the Turtle Island Light has made the Lighthouse Digest Doomsday List every year since 1993.

In 2002, an owner began construction of vacation cottages on Turtle Island. He also intended to restore the light as a bed-and-breakfast. Although these were fantastic ideas, the government intervened because the owner did not have a permit to build on the Michigan side. Rumors circulated that the developers continued on with the project but came to an abrupt halt in 2009 when a colossal-sized ice floe rammed into and obliterated both cottages before ever being used. Once again, the island refused any human contact.

The small dot, with its huge potential, remains uninhabited. The land continues to crumble back into the lake. With each season, the lighthouse skeleton continues to experience nature's most brutal attacks. Wil and Pat O'Connell write in their book, *Ohio Lighthouses*, "One day the island, the lighthouse, the retaining wall, and the Ohio-Michigan boundary will disappear under the waters of the lake, like the fabled city of Atlantis sinking into the ocean." Perhaps the island knew its fate long ago.

Chapter 4

Kelley's Island

Mystery in the Dark

The life of the dead is placed in the memory of the living.
—*Marcus Tullius Cicero*

Adult life had been rough for Elizabeth. For one, she had not found her soulmate until the age of twenty-seven. When she did finally meet and then marry James Selfe in her hometown of Brighton, England, she learned he had plans of eventually locating across the ocean to Canada. Thus, after ten years of marriage and the birth of six children, the couple packed up their belongings and readied for the trip. In 1868, the family made their way to Canada's Pelee Island in the western portion of Lake Erie.

Over the next three years, the Selfes struggled to make ends meet. So when a job opportunity at a quarry on Kelley's Island opened, James jumped at the chance. Once again, the couple relocated and set up house. They quickly found a rental home on Kelley's Island next to St. Michael's Catholic Church, not far from the quarry.

Tragically, in 1871, after just two weeks on Kelley's Island, James Selfe died of typhoid fever. Elizabeth was left widowed and penniless on an unfamiliar island. Ironically, the fact that she was stranded on the island may have been a blessing of sorts. One factor that prevails, even today, on Kelley's Island is the community closeness. So when the islanders learned of Elizabeth's distress, they quickly came to her aid. In fact, the Hamiltons, who owned most of the long point on the northern side of the island, offered Elizabeth a small house rent free on their wooded property. With whatever strength

she had left and for the love of her children, Elizabeth picked herself up and proceeded to move the family across the island.

For the next five years, Elizabeth struggled to get by. Even with the ever-encouraging support of her Kelley's Island family, Elizabeth had a rough time raising six children. Therefore, four of the children were sent to live with relatives. The other two children, James Jr. and the youngest, Jennie, remained with their mother on the island.

Yet even with so much upheaval in her life, Elizabeth was thought to be a strong woman who, according to the *Sandusky Register*, "was willing to help herself." So on June 25, 1877, when forty-seven-year-old Elizabeth Selfe was reported missing, the island community was completely mystified. In fact, the fate of Elizabeth Selfe still remains a mystery in the minds of most locals, even after 130 years.

Elizabeth's disappearance was odd from the start. From interviews with the children, officials were able to piece together the following timeline of events.

Around 6:00 p.m. on June 24, Elizabeth visited friends. The neighbors later stated that she seemed "cheerful and well." Around 7:00 p.m., Elizabeth returned to the cottage and prepared supper for the family. James reported that his mother ate heartily but complained of a headache. It was not until bedtime that circumstances became strange.

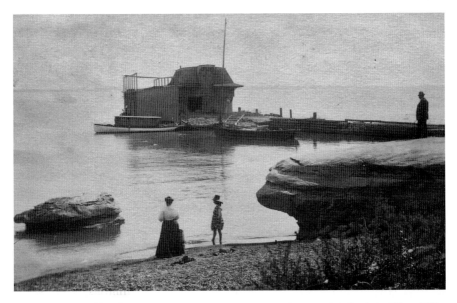

The shores and docks in the early days of Kelley's Island. *Courtesy of the Sandusky Library Follett House Museum Archives.*

A little after 9:00 p.m., Jennie fearfully told her mother that a man with a black hat was looking in the front window with his face very close to the glass. Elizabeth, wrapping a quilt around herself, went to the front room, where she quickly pulled the curtain closed. The mother told her daughter that she must have been mistaken about someone at the window and to go to sleep.

But a good night's rest was not to be had that evening. Both brother and sister were awakened sometime in the night by the anguished cries of their mother. Because Elizabeth always slept with the light on, they could see their mother on the floor between their beds, thrashing and yelling. When the children attempted to comfort Elizabeth, she only continued to moan. Eventually, she quieted somewhat and moved to the front room, where the children heard her pacing and mumbling long into the night. Sometime before dawn, James heard the front door open and then quietly shut again. He assumed his mother was headed out for some fresh air or perhaps to get an early start on the laundry. However, when Elizabeth had not returned by noon that day, James knew something was amiss.

For one, Elizabeth's shoes, her only pair, were sitting by the front door, along with her daily working dress. If she had gone to do laundry, she

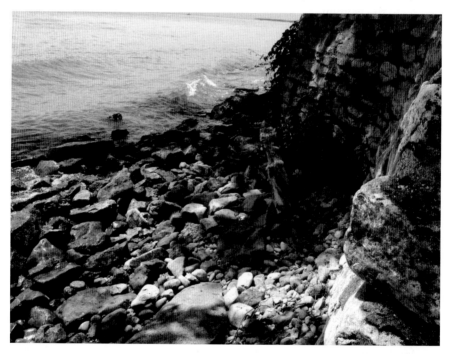

High cliffs on the northern-facing side of Kelley's Island. *Courtesy of Tim Dering, timdering.com.*

would have needed her shoes in order to traverse the rugged terrain just past the front yard. Secondly, Elizabeth's behavior during the night was completely out of character. And lastly, Elizabeth had never gone this long without the children knowing of her whereabouts. James realized he must seek assistance.

When officials arrived, with Justice of the Peace Howlette leading the group, it was immediately determined that Mrs. Selfe was in some sort of trouble. A search party was formed, and locals set to the task of looking for the missing woman.

Meanwhile, authorities interviewed the children and looked about the property. In James's small cabbage garden under the front window, they found a men's size twelve boot print. Upon further questioning, they learned that Elizabeth was fearful of a certain local man after he had attempted to embrace her about a year prior to the disappearance. She had angrily told the man to back off, which he did. After the incident, Elizabeth slept with a light on every night.

Near the lake, which was forty knots from the cottage, searchers found Elizabeth's undergarments, along with a black and white sack that did not belong to the woman. Some speculated that perhaps Mrs. Selfe had gone in the lake for bathing and drowned. Yet it did not make sense as to why she would traverse the rocky shoreline without her shoes. Others speculated that she may have climbed to one of the higher ledges and purposely jumped to her death. After all, she had been in what newspapers reported as "a fit of temporary mental derangement," as attested by her screaming and thrashing about the night before, according to the children.

Over the next week, islanders and local sailors searched for Mrs. Selfe. A twenty-five-dollar reward was offered for the recovery of her body. The prosecuting attorney from Sandusky was sent to the island to investigate the case after a week of having no clues surface. The local island man who had made a pass at Mrs. Selfe was never questioned, although islanders knew exactly who he was and where he was located on the island.

On July 7, eleven days after Elizabeth went missing, her body was found on the east side of the island. An inquest was called by the justice of the peace over her remains. When the verdict of suicide was called, some members of the inquest party refused to sign it. In fact, the island physician who examined the body was of the opinion that "Mrs. Selfe was foully dealt with" judging from the marking around her neck.

Islanders demanded a second inquest into the case, but to no avail. The case was ruled a suicide although the verdict was never accepted by the

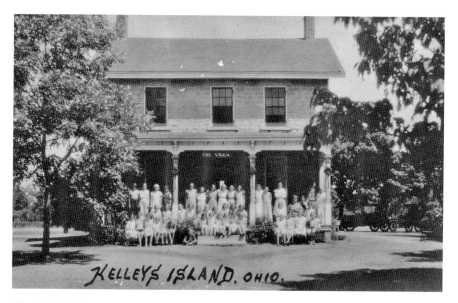

The dining hall at Camp Patmos. *Courtesy of the Sandusky Library Follett House Museum Archives.*

island folks, her friends and family. The Hamiltons continued to extend kindness to the Selfes and moved the children into their main house. Today, the swimming pool of Camp Patmos sits where the little cottage once was located.

The mystery of Elizabeth Selfe remains to this day.

Chapter 5

Pelee Island

Quarantined

The smallpox was always present, filling the church yards with corpses, tormenting with constant fears all whom it had stricken, leaving on those whose lives it spared the hideous traces of its power, turning the babe into a changeling at which the mother shuddered and making the eyes and cheeks of the big hearted maiden objects of horror to the lover.
—*T.B. McCauley*

In the late 1800s, the entire world lived in fear of one of the most deadly diseases of all times. Smallpox, also known as the "speckled monster," is believed to have killed 400 million people during the late 1700s alone. So when a case of smallpox was reported on Canada's Pelee Island, the American and Canadian health organizations took action immediately. Many issues played into the scare, and within weeks, the smallpox outbreak was reported to be of epidemic proportions. Between media sensationalism, island isolationism and numerous exposures to the virus as with the Pelee cases, the locals living on both the American and Canadian shores and islands prepared for and dreaded the worst.

Pelee Island, the largest of all the Lake Erie islands, sits just eight miles north of Kelley's Island. The international border cuts through the open water between the two. Oftentimes boaters, usually trolling for fish between the two islands, drift back and forth over the border without even realizing they are in another country.

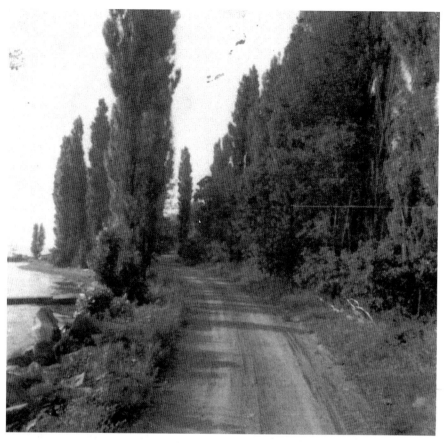

A road that loops around Pelee Island, 1930. *Courtesy of the Essex Kent Mennonite Historical Association.*

The township of Pelee is part of Essex County, Ontario, and includes nine other Canadian islands in the western Lake Erie basin. Pelee Island, approximately sixteen square miles, has always been known for the coexistence between its human inhabitants and its natural wilderness. In the early 1800s, European settlers arrived. They are credited with much of Essex County's peaceful heritage.

So in 1889, when a case of smallpox invaded this serenity, the island was plagued with more than the typical problems of the dreaded disease. For one, the island was considered hard to reach. Communication at this point was conducted through spotty telegraph services and the slow-paced mail system. Traffic to and from the island was carried out by seasonal ferry lines,

ships and small water vessels. So if or when an emergency were to arise on the island, help would be a long time coming.

Secondly, the media, whether from lack of knowledge or crafty storytelling, created unnecessary chaos in the already miserable situation unfolding on the island. Although only one person had officially been diagnosed, newspaper reports insinuated that the entire island was stricken with smallpox. Therefore, traffic to and from the island was detained or slowed down until a remedy was found.

The first factual report regarding smallpox on the island came on October 17, 1889, by telegraph from Dr. Hodgett. Apparently, a Dr. Snider of the island had visited friends in Toronto in late September. Not knowing he was infected with the virus, he returned to the island to work. However, a few days later, he began to have flu-like symptoms, including a high fever. After a few days, these symptoms let up. Dr. Snider reported feeling completely normal if not even better than usual. Yet, as is typical of the disease, the speckled monster soon reared its ugly head in the form of small blisters on his skin, eventually covering his entire body. Within hours, the doctor was viciously vomiting, experiencing delirium and spiking a fever of 104 degrees as his body sought to rid itself of the virus. The disease, and all its horror, was then in full form and ready to work its destruction.

Unfortunately, Dr. Snider boarded at the Island Home Hotel, an inn owned by a local island family. When health officials arrived, it was ordered that the Island Home owners "close the house against all persons except those exposed to the disease to thoroughly disinfect." This included the burning of sulfur to fumigate the building and the burning of bedding and any other clothes in the home. Dr. Snider was moved to the house of Henry Mickle, a close friend.

Perhaps the most frightening situation was the fact that Dr. Snider's best friend, a local teacher on the island, saw to the chore of caring for his sick comrade. It is believed that the schoolteacher was initially unaware of the risk he was taking. In the evenings, he would attend the needs of his sickly friend, and during the day, the schoolteacher returned to his job of teaching his nearly fifty pupils at schoolhouse number 1.

In the meantime, news reports cropped up throughout the nation about the "ill-fated island." Many newspapers reported up to one hundred cases on the island, half of which were supposedly the children of schoolhouse number 1. According to sources, there was not a house on Pelee Island without one to three cases of smallpox. In fact, the epidemic was spreading so rapidly that one paper reported that every inhabitant of the island would surely contract

Schoolhouse number 1 on Pelee Island, 1930. *Courtesy of the Essex Kent Mennonite Historical Association.*

and most likely die from the disease. When an official quarantine was issued, it was reported that "all avenues of escape from the place have been closed by American and Canadian authorities."

While the reporters thoughtfully covered the story, health officials sought methods to handle the situation. Dr. Hodgett of the island, who originally diagnosed Dr. Snider, was instrumental in communicating with the Ontario and American health departments. Dr. Hodgett saw to the task of quarantining those exposed. The health department quickly closed the Island Home Hotel and all schools, churches and businesses on the island. Locals were advised to avoid social contact until further notice. Ports in Ohio and other islands were blocked to anyone from Pelee Island without a certificate signed by Dr. Hodgett. Anything and everything that could have been touched by someone exposed was carefully disinfected. Any bedding or clothes exposed were quickly burned.

Dr. Hodgett, as well as members of the island's local board of health, who were immunized against the disease, worked to vaccinate every person on the island, approximately five hundred citizens. In the Eighth Annual Report of Provincial Board of Health of Ontario, it was stated that "too much praise cannot be bestowed on the local board who, wholly unused to dealing with outbreaks of disease, took such prompt measures to secure within a few days the vaccination of every person on its island, and to isolate the attacked."

Due to the swift action of health officials, only six cases ever appeared on the island. Sadly, three of the cases were found within the Mickle family, a young daughter included. The other two cases included Dr. Snider and the teacher, both of whom survived. The Ontario Department of Health reported that there was one death, an A.M. McCormick, associated with the smallpox scare.

By the turn of the century, nearly one thousand inhabitants lived on the island. The smallpox epidemic had left a scar on the island, as it did anywhere it reared itself. Yet Pelee Island, with the cooperation of all involved, fought against such a calamity and restored its reputation of peace and serenity.

Chapter 6

Put-in-Bay

Hotel Victory

Memory is the treasure house of the mind wherein the monuments thereof are kept and preserved.
—Thomas Fuller

It was recorded in the books as the largest and most magnificent hotel in the world. Not even the famed Ponce De Leon Hotel of Florida could rival this massive lodging on South Bass Island at Put-in-Bay. In fact, ship captains reportedly could see the lights from the hotel as far as thirty miles away. Yet the Hotel Victory, in all its splendor, was not to be victorious in any sense of the word. Miserably, just thirty years after the grand opening, ship captains would again report seeing the light from the Hotel Victory as hot orange flames shot into the Lake Erie night sky.

The vision started with businessman John Tilloston from the Toledo area. In the early 1880s, Tilloston took note of the booming tourist business concerning South Bass Island, also known as Put-in-Bay. With several financial investors backing his vision in 1888, Tilloston started the Put-in-Bay Hotel Company. With $250,000 in hand, the company began plans for Hotel Victory. In September 1889, at Put-in-Bay's annual Perry's Victory Celebration, the cornerstone for the grandiose hotel was laid on the southwest shore of the island.

From the get-go, several setbacks occurred. Originally, the hotel was to be opened in the summer of 1889, but several of the original investors backed out. Whether from mistrust or financial strain, the investors suddenly jumped

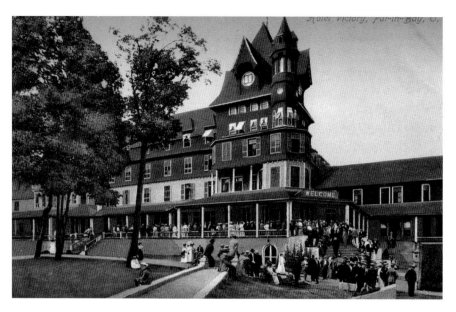

Hotel Victory postcard. *Courtesy of the Sandusky Library Follett House Museum Archives.*

ship, leaving Tilloston in economic hardship. Nonetheless, Tilloston pushed on, and in July 1892, three years after its intended opening, a partially complete Hotel Victory opened. With 275 carpenters and electricians receiving half a day off, a four-hour buffet dinner was served to over 500 guests in honor of the grand opening.

Although the construction was not completed, the dinner guests were treated to a tour. As promised, the Hotel Victory was the largest of its day. With 650 lavishly furnished guestrooms with either a lake or courtyard view, the hotel was able to accommodate approximately 1,500 overnight guests. The hallways, completely carpeted, measured nearly a mile in length. Three elevators operated to carry guests to all five floors, each level with its own bellboy service station. If this weren't impressive enough, the hotel included three dining rooms: one for formal dining, one for casual and one for hired nannies responsible for small children. The one-hundred-foot-long kitchen, of course, was stocked with every modern amenity known at the time in order to prepare exquisite meals. Luxurious ladies' parlors, a ten-table billiard room, a massive ballroom, a thirty-foot-long bar and an inner courtyard added to the grandeur.

The grounds, likewise, were not to disappoint. When planning the location for his hotel, Tilloston had chosen wisely. Only upon the highest

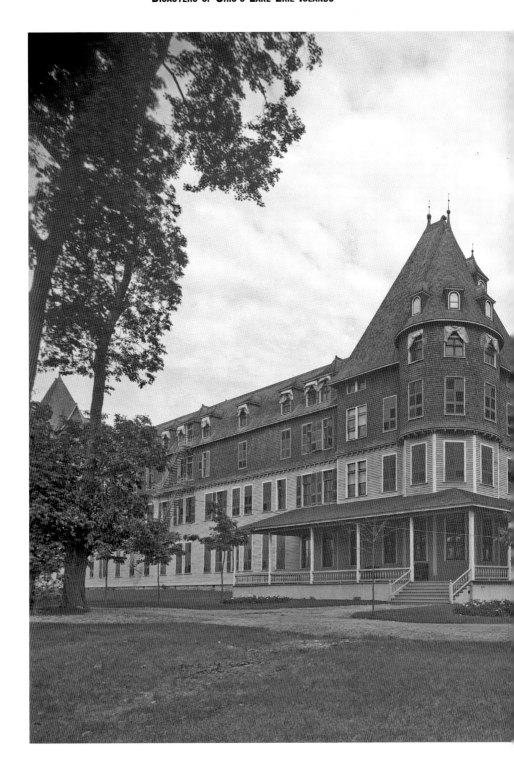

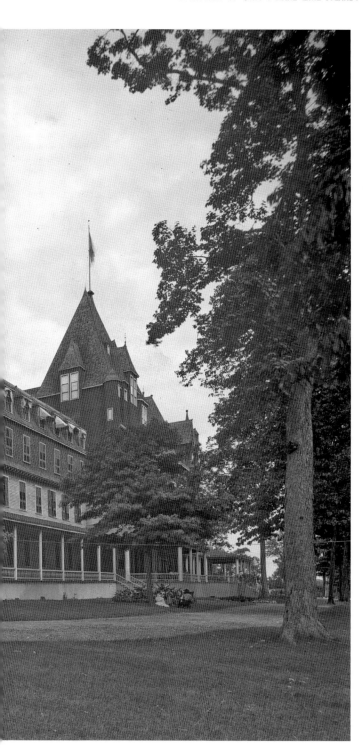

Hotel Victory photograph around the time of the grand opening. *Courtesy of the Library of Congress Digital Collections.*

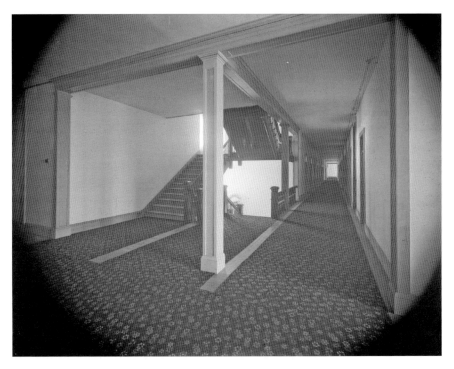

Interior hall of Hotel Victory. *Courtesy of the Library of Congress Digital Collections.*

point of South Bass Island could the Hotel Victory be constructed. According to the *Toledo Blade*, a well-known realtor of the time proclaimed after a visit to the island that "Tilloston and his enterprising band of followers have pitched their tent on the topmost pinnacle of one of the finest islands in the American chain of lakes. This little band is entitled to the everlasting gratitude of a pleasure-seeking public for the discovery of one of the most magnificent natural parks on the American continent." Another reporter from the *Blade* explained that with "the rugged nature of the ground with its bold and picturesque shore, its rocks, cliffs, gorges, caves, bluffs, ravines and dells, formed a variety of scenery that thousands of dollars could not have made." Tilloston capitalized on this natural beauty in every way imaginable.

On the twenty acres of land, gardens and fountains along the mile of walking paths greeted guests at every turn. Iron staircases led down to the sandy beaches of Lake Erie. A rustic bridge spanned a ravine that led into a cleared serene park, known as Victory Park. Gated overlooks perched upon the high bluffs to take in the beauty of the island and lake.

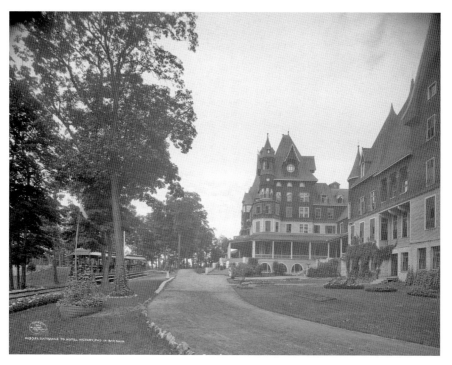

Driveway leading to the hotel. *Courtesy of the Library of Congress Digital Collections.*

Included in the hotel stay was the use of two unique amenities. First, guests were encouraged to use the natatorium, which was a covered swimming pool. Years later, it would be advertised as the first coed swimming facility in America. Second, the guests enjoyed transportation to and from the hotel on an electric railroad built specifically for Hotel Victory. Guests boarded the ninety-six-seat open trolley at Peach Point, where the tourist ferries docked. The trolley then transported guests right to the front entrance of the hotel. Additionally, the trolley ran to and from Perry's Cave and the downtown area if one were inclined to tour the island. It was reported that during the busiest parts of the day, a train of three cars ran every five minutes.

No pleasure, luxury or comfort was left undone in the design of this hotel. Yet all this came with a price. And one man's dream would become his nightmare by the following year.

Apparently, Tilloston was unable to pay debts that he owed to construction crews, furniture companies and property tax. One article noted that he was never a man of "paying proposition." Even the silverware in the hotel had not been paid in full. Thus, in August 1893, Tilloston asked the nearly fifty

end-of-season guests to leave the hotel at the order of the United States marshal. The Hotel Victory was nicknamed "Tilloston's Nightmare."

For the next two years, the Hotel Victory sat vacant and neglected. In 1894, a reporter for the *Toledo News* wrote of the horrible condition of the hotel and grounds: "The immense structure, representing thousands and thousands of dollars, is nothing simply but a home for bugs, rattlesnakes and June bugs. The windows are so thickly covered with June bugs that it is impossible to look through them, and Victory Park—J.K. Tilloston's dream—is today a cow pasture." The reporter went on to explain that the property was such a fire hazard that "a match or cigar stub carelessly thrown near the structure would start such a fire as was never seen before on the island."

In 1895, the hotel and property were auctioned off for a mere $17,000, about one-fifteenth of the original construction and land price. Only two interested parties bid at the auction, and the sale was completed within ten minutes. The new owners, the Ryan brothers, set to properly caring for their new investment.

By the 1896 grand reopening, the entire hotel was completely finished. Every wall, carpet and pillar was built and/or repaired to perfection. The most effective move of the new owners was to hire a hotel manager by the name of Thomas McCreary. McCreary, of Ashtabula, soon became known as a master of marketing strategies. His specialty was advertising and catering to companies in need of convention accommodations. The hotelier was also known for his hospitality and good nature. Over the next ten years, under the keen leadership of McCreary, Hotel Victory entered its heyday years.

When McCreary died of natural causes in 1907, the owners hired a new manager. However, the magic that McCreary brought to the hotel seemed to die with him. In 1909, the hotel was closed once again. Over the next decade, buyers attempted to make a go of the Hotel Victory, but it never seemed to work out. In 1919, after being perfectly refurbished, the Hotel Victory opened for the season for the very last time.

On August 14, 1919, business was slow as usual. Therefore, only forty people occupied some of the 625 rooms. At 7:00 p.m., an electrical fire broke out on one of the upper floors, possibly in the cupola. Within a few hours, the entire massive structure was engulfed in flames. People as far inland as Oak Harbor reported seeing the reddened sky. For locals and tourists closer to shore on the mainland, such as those in Port Clinton, the flames appeared to be shooting at least seventy-five feet high. With only very slow communication from the island, many believed the entire island of Put-in-Bay must be encompassed with flames.

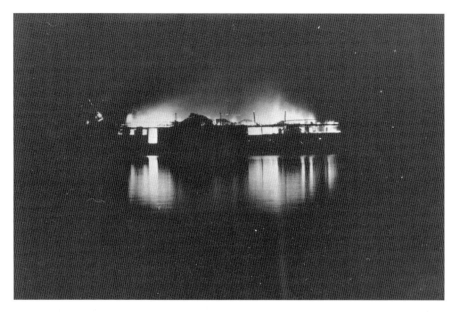

The fire at Hotel Victory. *Courtesy of the Sandusky Library Follett House Museum Archives.*

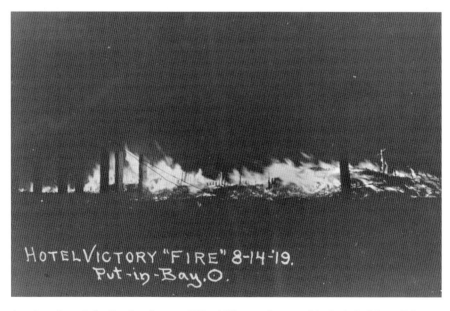

Another view of the fire that destroyed Hotel Victory. *Courtesy of the Sandusky Library Follett House Museum Archives.*

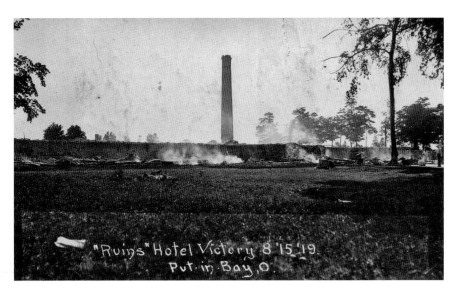

Hotel Victory almost completely leveled by the fire. *Courtesy of the Sandusky Library Follett House Museum Archives.*

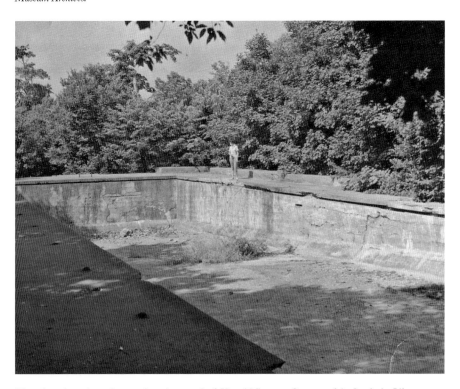

The abandoned outdoor swimming pool of Hotel Victory. *Courtesy of the Sandusky Library Follett House Museum Archives.*

Luckily, all the hotel guests and employees escaped the fire unharmed. As for the beautiful and grandiose Hotel Victory, it did not fare as well. Within roughly two hours of the start of the fire, the glorious structure was reduced to nothing but rubble and ash.

Today, tourists can still visit Victory Park, were a statue was erected to celebrate Perry's victory. The cement outline of a swimming pool can also be found near the park. Although ship captains no longer see the lights of the Hotel Victory shining over the darkness, the story of such a place brings delight to many.

Chapter 7
Kelley's Island

The Ruins

Time doesn't stop in abandoned buildings, it just moves differently.
—Jane Derenowski, NBC News

No Trespassing—Dangerous Area" signs speak their message loud and clear from dozens of trees surrounding the area where Cameron Road ends near the western shores of the island. It's obvious that the road continued on at one point in time, as witnessed by the wide dirt path curving deep into the woods. Local police officers of Kelley's Island receive calls from concerned neighbors of the area on a regular basis as curious visitors are drawn to the location. With all the other impressive sights of Kelley's Island, what could be so fascinating that numerous people are willing to endanger themselves to see?

It all started with the planting of one grape cutting in 1842. Datus Kelley, from whom the island takes its name, had successfully bought and began quarrying the island. Perhaps Kelley knew of the successful grape harvesting happening along the Ohio River at the time, for he planted the little Concord grape cutting as a fun experiment. To his delight, the small plant developed into a huge vine producing massive amounts of sweet rounded fruit. In 1846, he planted an acre's worth of the plant and easily earned $5 on his crop. By the 1860s, now with acres of vines, the crop brought in $51,000. And by the 1870s, the grapes brought in a whopping $150,000. Thirty years later, vintners all across the island could be found bottling the grapes into sweet, light-tasting wines still popular in

the Lake Erie region. Popular wineries of today such as Sweet Valley were established during this era as well.

The Kelleys, as well as settlers on the other islands, had discovered the perfect microenvironment for growing grapes. Lake Erie seemingly has a magical effect on the product. According to Johnson's Estate Winery in New York, the grapevines need a perfect balance between warmth and cold. In the warmer months, the grapes need approximately 1,500 hours of sunlight which is found near the lake. Likewise, during the summer months, the lake absorbs a vast amount of heat, which it releases during the fall. This allows for a longer growing season, into late October, which produces more grapes. As for the extreme winter months, the lake actually keeps the shores and islands five to fifteen degrees warmer than the interior of Ohio. This also inhibits the grapevines from budding until mid-April, when the threat of heavy frost has passed. With this perfect grape-growing environment, the islands and other southern lakeshore regions became some of the most prosperous wine-producing lands in America.

On Kelley's Island, Datus Kelley's son-in-law is credited with establishing not only the first winery north of Cincinnati but also one of the largest wineries ever on Kelley's Island. In 1851, Charles built his first wine cellar. In 1853, he took his wine to the Ohio State Fair, where it won first prize, bringing it national notoriety. By 1857, with new employees from wine districts of Germany, the island had nearly seventy acres of grapevines. Around 1860, the island furnished the ground for 230 acres for grape farming. The island, with its limestone quarries, natural beauty and history and now over 200,000 gallons up for sale, was quickly becoming a favorite tourist attraction.

With all this wine production, Charles Carpenter realized that his companies and the other newly established wineries on the island would need a place to store their vast inventory. The island's geographical makeup once again proved to be perfect for such a task. The deep limestone underbelly of the island offered a cool, dry place to create ideal wine cellars. In 1851, Charles opened the first wine cellar on the island. The success of Carpenter's cellar propelled the establishment of the Kelley's Island Wine Company.

The new company built in 1865 was established as a cooperative for island wine producers. The smaller wineries joined the cooperation, as the Kelley's Island Wine Company could better market the wines. The company also rented cellar space in the huge underground tunnels, two stories deep, built to hold up to 500,000 gallons of wine. For years, the company thrived as grapes were brought to the huge production and storage facilities.

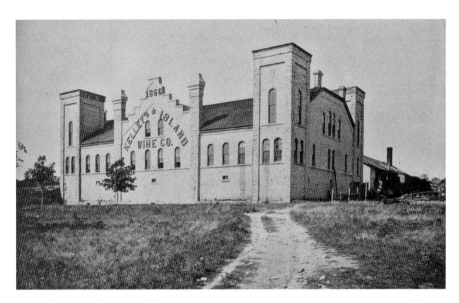

Kelley's Island Wine Company in its days of operation. *Courtesy of the Sandusky Library Follett House Museum Archives.*

The Kelley's Island Historical Preservation Society tells of a time when a famous botanist visited the facility and described the efficient process of wine cooperation. French botanist J.E. Planchor visited the winery in 1873 and described how the winery worked. Grapes were brought in by wagons from all over the island, weighed, paid for on the spot and sent by a steam-driven conveyor to the top floor of the winery, where they were crushed and destemmed and the juice separated from the skins. The juice then went to the fermentation vats on the second floor, while the skins descended to the ground floor, where six great steam-powered presses, each one capable of handling three tons of material in six hours, awaited them. Below ground were two levels of vaulted cellars for the storage of wine in both casks and bottles, including champagne storage. The wines were made and bottled as varietals, including Concord, Ives Seedling, Delaware, Isabella and Iona. Wine was shipped from the south dock.

Because many of the buildings on the islands are exposed to winds, even a little spark can become a raging inferno. The first fire to consume the Kelley's Island Wine Company occurred in September 1876. The company was not fully demolished, but a complete facelift occurred. The reconstruction included walls built from the limestone of the island. The massive structure now resembled a castle from the Middle Ages. In 1915, the winery burned

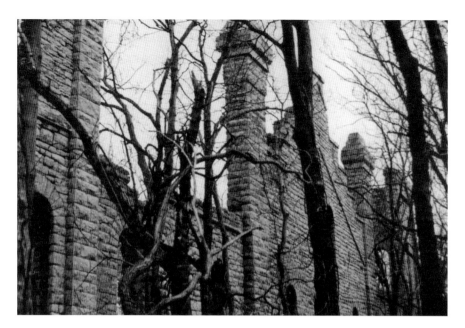

The ruins of Kelley's Island Wine Company. *Courtesy of the Sandusky Library Follett House Museum Archives.*

once again, but its owners were not about to let it go down in flames with the immense amount of wealth it brought to their pockets. Although the fire had destroyed thousands of casks of inventory, the building was refurbished and reopened. Then in 1933, a grass fire nearby took hold of the vacant company. The building had been vacant for thirteen years due to Prohibition laws. This time, the owners did not seek to rebuild the company.

Over eighty years later, the skeleton of the once thriving wine company still stands among the thick woodsy trees. The off-limits remains, located on private property, often prove to be a great temptation for curious explorers and photographers. However, the towering, crumbling frame presents a dangerous situation for anyone in the vicinity. Buried and weakening wine cellars are very likely to cave in with additional weight. Still, people are drawn as the castle-like walls whisper of a history not often mentioned in books. The remnants not only add to the intrigue of island history but also symbolize the origins of a prosperous and much-loved island attraction, Lake Erie wines.

Chapter 8
The Success of a Prison Ship

History is a gallery of pictures in which there are few originals and many copies.
—Alexis de Tocqueville

For nearly fifty years, the creaking mammoth of a ship sailed the seas and Great Lakes as a horror show on water. Millions of Europeans and Americans toured the decks and holds of the vessel in order to glimpse relics designed for human suffering. Delicious tales of horror, cruelty and death could be enjoyed on the floating torture chamber. The convict ship, *Success*, promised a one-of-a-kind view into "the darkest chapter in England's history." Yes, aboard this old gal, folks were treated to the viewing of every torture device known to man. These morbidly fascinating objects were presented as mechanisms used to keep England's worst prisoners in line. Not only that, but the *Success* was advertised as the world's oldest ship. Although most stories, including the torture tales, were dramatized or even made up, the *Success*, cursed convict ship or not, still has an intriguing journey and a disastrous and unnecessary fate that deserves a place in shipping and Lake Erie history.

Built in Burma in 1790, the humongous vessel was constructed for heavy lumber transportation. For a time, the ship made its way back and forth on the Indian coast hauling a cargo of teakwood. At one point, it was commissioned for a voyage to London to be sold to a merchant company there. But as fate would have it, the ship ran aground on a reef. When it

finally made it to England, it was sold to a company that was near financial ruin. Thus, the ship that would one day attract millions sat rotting away in an old English shipyard.

In 1842, new owners took note of the ship with an innovative purpose in mind. The new proprietors planned to transport immigrants to the newly formed Australian colonies along the coast in need of laborers. In order to make the now rustic-looking ship more appealing, the clever owners replaced the figurehead with an attractive iron bust of a woman's torso.

While sailing as an immigrant ship, the *Success* was continually plagued with misfortunes, including another wreck on a reef as well as later capsizing and killing several sailors. Regardless, for ten years, the *Success* carried thousands of immigrants and sometime indentured servants to ports in Australia. Eventually, the ship was deserted by the entire crew while docked near Melbourne. Apparently, the entire region was successfully experiencing a gold rush. Every last sailor opted to be part of this new golden venture.

During the 1850s, the Victorian gold rush was at its peak. Rumors of the riches found on the Australian coastline brought treasure hunters by the droves, nearly tripling the population of the new colonies. Between the extreme growth in population and the fight to obtain the best gold mines, crime became prevalent throughout the colonies. A need to confine and punish these criminals emerged. A huge hulking ship sitting unused in the bay offered the solution.

The *Success* and several other similar ships were fitted out with rows and rows of cells. Here, gentlemen who could not behave themselves during the gold rush in the colonies were housed during their sentence. As with almost all historic prison systems of the old world, the conditions aboard the ship were not luxurious. Prisoners spent their days in tiny cells, some below deck in the dark, dank bowels of the vessel. Although conditions were far from pleasant, there was never a collection of torture devices, as would later be advertised.

In 1857, after penal ship prisoners working in the nearby quarry attacked and killed the superintendent of prisons, the ship was converted to hold refractory sailors, women and young boys in need of reform. Over the next few decades, the ship bobbed quietly in the bay, hosting the less hostile prisoners.

Near the turn of the century, however, the story of the *Success* took a drastic turn. In 1890, the ship was sold at auction. The new owner's plans were to convert the ship into a hauling ship again. However, this idea quickly changed once the owner realized he could capitalize on the history of the ship. Thus, the ship was turned into a floating history museum showcasing the brutalities of a convict ship.

The *Success* docked at one of many docks for touring pleasure. *Courtesy of the Ottawa Historical Museum.*

Wax dummies dressed in prisoner uniforms were placed aboard the ship. These replicas were sprawled out on the cell floors, positioned as though wasting away. Iron balls and chains were purchased and placed on the waxed figures. Whipping devices were obtained and brought on board so that all could see the abuses bestowed upon all on the convict ship.

After a few profitable months at Melbourne, it sailed to Sydney, Australia. Here it is believed that many detested the history portrayed on board, and the ship was vandalized. Nonetheless, the museum continued to draw large paying crowds to its decks. So when the ship caught fire and sank in 1891, the owners worked to have it refloated after a five-month rest at the bottom of the bay. The cost to resurrect the vessel was well worth the venture. Over the next few years, the *Success* sailed around Europe as a one-of-a-kind artifact. But why stop there? For just across the ocean was a country filled with many curious and gullible Americans.

In 1912, an American buyer realized the profit-making potential for a grisly exhibition ship such as this. He made his purchase and sailed his investment to Boston, where it was fitted out with not only torture devices

The rigging aboard the *Success*. *Courtesy of the Ottawa Historical Museum.*

but also tales of horror, to the delight of Americans. For the next forty years, the prison hulk sailed the American coastlines, inland seas and even into the Ohio and Mississippi Rivers, welcoming millions of tourists aboard. In 1933, the ship was featured at the Chicago World's Fair, and it continued a successful tour on the Great Lakes for the next decade.

Once paying tourists boarded the ship, they were treated to the most horrifying display of torturous devices known to man. These devices were supposedly used aboard many of the British convict ships and were on display for all who wished to envision the misery each contraption could likely produce. On top deck, tourists viewed the branding station, where prisoners had a number seared into their hand with red-hot irons. Flogging whips were laid tangled about the decks. Once a prisoner took his whippings, he was dunked into a sea salt bath, the salt burning into his fresh wounds. Of course, iron chains and balls were sprinkled about to suggest that prisoners were chained to their cells. On one wall display hung a spiked collar that could be hooked to such chains if need be. Yet another favorite attraction

Opposite: A wax figure representing a prisoner slumped in his cell below decks. *Courtesy of the State Library of Victoria.*

Below: Torture mechanisms displayed as part of the floating museum. *Courtesy of the Ottawa Historical Museum.*

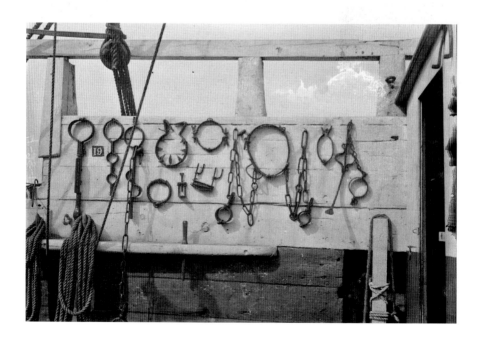

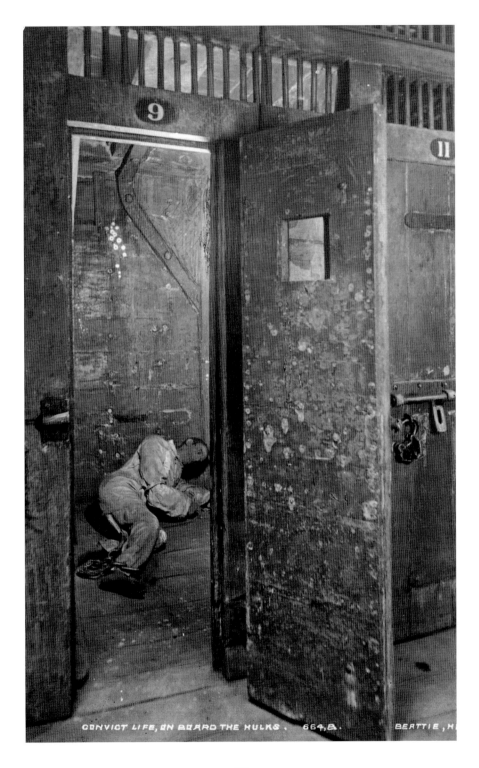

on deck was and is one of the most infamous punishment mechanisms of all history, the iron maiden. This concept is believed to have originated during the Middle Ages. The contraption stood upright with a hinged door and spiked walls. It was tall enough to confine a man for as long as his punishers saw fit. The famous wax figures were placed throughout the ship, most in cells, to better set the mood. On the lower decks, onlookers could experience the dankest of conditions, including solitary confinement, along with various more pain-inflicting gadgets. Somewhere on the ship was a quaint gift shop where customers could purchase further reading about life aboard the convict ship. Souvenirs and postcards depicting grisly images were readily available for those who wished to remember such an intriguing and enjoyable attraction. American tourists were not let down by their time aboard the *Success*.

In 1936, the *Success* dropped anchor on the shore of Cleveland as part of the Great Lakes Exposition. Here it was stationed for several years, marking its last big show. As the printed advertisement stated, "Once she leaves, she will never return"—an unintentional forecast into the ship's soon-to-be fate.

After the Great Lakes Exposition, the ship was sailed to Sandusky by its new owner from Indiana. Although the ship was built of the strongest of woods, the old girl was now approaching 150 years old, with several wrecks and sinkings in its history. And just like many strong ships before it, the *Success* could not withstand a devastating blow that came in the form of a Lake Erie storm in 1942. The convict ship was once again fully submerged in its moorings.

In one last attempt to save the old relic, a local man purchased

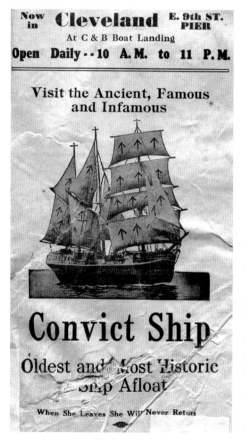

A pamphlet advertising the *Success* at Cleveland's Great Lake's Exposition of 1936. *Courtesy of the Ottawa Historical Museum.*

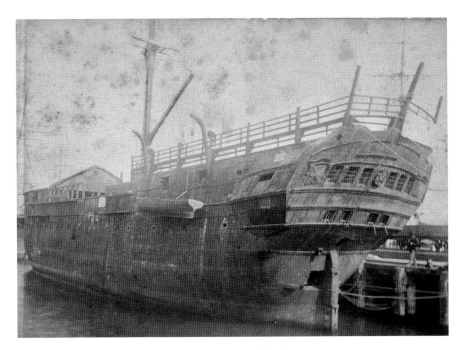

Success in its later years. *Courtesy of the State Library of Victoria.*

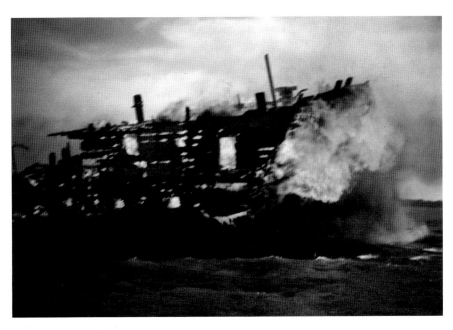

Success fully engulfed in a fire off Port Clinton. *Courtesy of the Ottawa Historical Museum.*

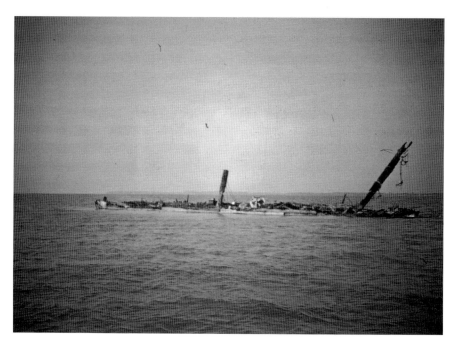

Success burned to the waterline. *Courtesy of the Ottawa Historical Museum.*

the rights to the *Success*. He had the ship towed and anchored between Port Clinton and South Bass Island. But another successful season was not to be. On July 4, 1946, the historical ship was set on fire, most likely by area vandals, and burned to the waterline. The convict ship was no more.

Today, divers favor the remnants of the ship on the bottom of Lake Erie not for its outstanding beauty but more for the history associated with the *Success*. Authors and professional divers Georgann and Mike Wachter write that the *Success* is "a vessel whose remains might lack luster but with such a great story that a diver wants the chance to touch her at least once." Likewise, Richard Norgard of Port Clinton, to whom much factual research is attributed, has spent years of his life writing and researching the true story of the *Success*. Currently, he is working on a book tentatively entitled "Heart of Teak" and has several information-packed websites devoted to his research on the ship. He writes, "My desire is to preserve her legacy for others to study and enjoy." Perhaps one day, the *Success* will find its place in history.

Chapter 9

North Bass Island

At Peace

Oh Saint George, the Gem of Lake Erie
The home of the good and the true
The Mecca of travels aweary
My heart offers tribute to you!

The sweet, thick smell of the ripened grapes permeates the entire island. Rose, now ninety years of age, inhales deeply as she steps off the dock and onto the solid ground of the island. Her life on the mainland has been good, as attested by her kind-hearted great-grandson helping her trudge along on her walk. Yet for the sixty-five years she has been away from the Isle of St. George, a part of her heart has remained there, interwoven with the grapevines. North Bass Island, with all its beauty and memories, is the one place she needed to see before leaving this life.

Just two miles south of Canadian waters, North Bass Island—originally known as Bass Island No. 3—remains the only of Ohio's Lake Erie islands virtually untouched by the hand of tourism. Early settlers learned quickly that the land was extremely fertile for growing grapes. By the time the Fox brothers purchased and cleared two hundred of the nearly seven hundred acres, the grape-growing industry was already trending among the other Bass islands in the mid-1800s. Within a few years, five hundred acres of the island were covered in rows upon rows of the spindly twirling plants. The Fox brothers rented or sold parcels of their land, and new grape farmers made the island their home.

If not successful by way of grapes, many island entrepreneurs made their living by way of fish. The area around North Bass Island has always been known for its population of fish due to the many reefs beneath the deep waters of the area. Additionally, on the southwest rounded corner of the island is Manila Bay. This sheltered bay offered fishermen a place to fish, regroup and easily dock. From fishing to boat building, a career in the fishing industry was another lucrative choice for those making their way up north.

With the successful trades, the island population grew to its record of nearly two hundred permanent citizens. With this growth spurt came a need for a few small village essentials. This included the only church, the Congregational church; a one-room schoolhouse; a twine shop for the many fishing nets needing to be built and mended on the islands; and an airstrip. In 1874, the island petitioned to have a post office. After several postal mix-ups, the locals requested that the name of the post office be changed from North Bass Island Post Office to Isle of Saint George Post Office. Consequently, the island is often referred to as the Isle of Saint George, although the word "Saint" was always abbreviated to "St." on wine bottles for religious purposes. Two paved roads were established, mainly used for hauling grapes to the shorelines to be shipped. Eventually, a steamship by the name of *Parsons* appeared on scene, owned by the Fox brothers. This allowed for families to come and go on the island more easily. But even with the few conveniences, life on the island revolved around the grape-growing busy seasons, which encompassed the seasons of spring, summer and fall. Thus, there was never much need for an active town center. North Bass Islanders were content to live and work on their peaceful lands without the touristy crowds.

Yet even with a routine working schedule, the small population and the laidback style of the island, North Bass Island, as with its island neighbors, was not immune to tragedies.

In 1905, islanders were shocked to learn of the death of old Tommy Dunn. Tommy had been known for years as one of the best boat builders and boat repairmen of not only North Bass Island but of all Ohio's Lake Erie islands. A man of few words, Tommy chose to live his life much like a hermit. Consequently, he lived in a tiny apartment off an old boat shed on Manila Bay. So when Tommy sank into a depression, no one noticed. On the morning of September 6, a customer came to inquire of his boat. As he made his way toward the back of the boathouse where Tommy lived, the customer called out for the older fellow. After receiving no answer, the man pushed the unlocked back door open. To his horror, there was Tommy Dunn

dangling from the rafters. It was immediately decided that the old man had taken his own life by way of hanging. The reasoning for this tragedy was never determined.

Around this time, Rose Lescheid, the only daughter of John and Rose Lescheid, was a thirteen-year-old girl running free around the island when not attending school. Living at the north end of North Bass Island, Rose enjoyed playing about the vineyards leading right up to the lakeshore.

Meanwhile, Walter Siefield, one of three children to grape-growing tycoon Rudolf Siefield, spent his days picking grapes and reporting for classes at Oak Harbor High School on the mainland. His parents had stressed early on that education was important and encouraged their son to pursue it. So when Walter graduated high school, he continued on to Sandusky Business School and then to the Ohio State University. With a fine education under his belt, he now returned to his hometown of Isle of Saint George to learn the family business. For a time, Walter concentrated on his business aspirations. That is, until he noticed a beautiful girl right across the lane at the neighbor's place.

Apparently, Rose Lescheid was no longer the scrawny girl next door skipping around the fields. While Walter had been busy harvesting his education, the neighbor girl had been blossoming into a fine young woman. Walter, with his dark looks and strong build, was surely noticed by the young woman. Eventually, the two neighbors found soul mates in each other.

The fairy tale romance on a beautiful island resulted in a wedding for the two on June 5, 1914. Rose, a blushing bride of twenty-one, and Walter, a handsome bridegroom at twenty-four, promised their love "'til death do us part" at the Congregational church that early summer afternoon. A reception for the newlyweds soon followed at the Siefield home.

Laughter and wine were plenty that day. A storybook romance, an island wedding and a promise of a bright future glowed brighter than the June sun off the lake. How could anyone know that such a perfect day would turn tragic in a moment's time?

As part of the reception celebration, all the men of the island had brought their rifles to fire off a salute for the new couple. After the firing, several folks went to sit on the large wraparound porch of the Siefield house. The bridegroom happily perched on the steps leading up to the porch to give his guests the best seats. As it were, one guest had placed his gun against the wall behind his chair. Leaning back, the guest pushed his chair, accidentally knocking the gun to the floor. The rifle fired, to the horror of the guests. As if in slow motion, several guests realized that someone had received the bullet from the gun. Walter Siefield lay gasping for breath on the front steps.

Nine days after the wedding ceremony, the same wedding guests attended Walter's funeral at the tiny Isle of Saint George Cemetery.

Not long after the tragedy, Rose and her parents moved from the island, the pain too much to bear for the daughter, now a widow. Rose, in her grief, wished to leave that cursed island and never look back. And for over half a century, Rose did just that. She remarried, had children and grandchildren and was able to enjoy a contented life. Yet a part of her could never completely let go of her island home. Sometimes on hot summer days, an unexpected cool breeze would pass through, and she would catch her breath as she remembered the winds off the lake. And every so often in her busy life as a mother and wife, the thick, sweet smell of sun-ripened grapes would infiltrate her kitchen as she busily completed her chores. It was in moments like these that Rose would think about the island, her memories and her lost love.

In 1980, a North Bass Island local received a call from a young man. The young man stated that he would like to bring his grandmother to the island for a visit. The island man was delighted to offer assistance when he learned the elderly lady was returning for the first time since 1914. In fact, the islander offered his car to the man and his grandmother so they could visit the island in its entirety.

As Rose stepped onto the island, she paused. The Isle of Saint George was exactly as she had remembered it. A gentle serenity enveloped her heart, just as the scent of the September grapes encircled the island. As she visited the old property, the grape harbors, the churchyard and the small cemetery that early fall day, she allowed the memories to flow. And instead of a crushing heartache for what could have been, Rose found her heart was finally at peace with her memories, her island and her life.

Nowadays, twenty-four residents live on North Bass Island. Four paved roads crisscross the island; these are adequate, as tourism has never been adopted. The State of Ohio has acquired 589 acres of the island for use as North Bass Island State Park. Primitive camping with a permit, hiking and shore fishing are encouraged for guests wishing to experience island nature at its best. There is no ferry service to the island. Visitors can only disembark by plane or personal watercraft.

Another one hundred acres or so is still used to cultivate grapes for winemaking purposes. The grape harbors at the Isle of Saint George are designated as an American Viticulture Area. This achievement deems that the grapes have been grown in a unique environment producing some of the finest wines of the area.

North Bass Island, or the Isle of Saint George, remains one of the most peaceful islands of the Lake Erie island archipelago.

Chapter 10

Kelley's Island

A Call in the Night

There is no greater love than this, that a man should lay down his life for his friends.
—Saint John

Oftentimes when tourists visit an island, they question what would happen in an emergency. On the Lake Erie islands in particular, there is not a hospital with a twenty-four-hour emergency room. Therefore, what would locals do in the midst of winter if an emergency were to occur? Sometimes, it takes a disaster of dire consequences to have this issue addressed. Such is the case of Kelley's Island and its incredible emergency medical service origins.

On a blustery cold night on Kelley's Island, December 10, 1983, Police Chief Norby McKillips realized that something was terribly wrong. The fifty-six-year-old, trained in some medical knowledge over his thirty-two-year stint as police chief, recognized at once that his body was showing signs of a heart attack.

As word spread, a call to the Ottawa County deputy sheriff, Bruce Mettler, was placed. Mettler was stationed at South Bass Island and placed a call to a mainland pilot, Robert Rigoni. The pilot quickly readied his plane and flew to Put-in-Bay. Mettler and two paramedics, Michael Sweeney and Duane Dress, hopped aboard the plane around 9:30 p.m., and Rigoni radioed to the fire chief to "be advised, we're airborne."

The three of four airborne men made up the first organized EMS squad in Put-in-Bay. In 1977, Mettler and his wife, a dispatcher on the island,

A bird's-eye view of Kelley's Island. *From Wikimedia Commons.*

had moved to the island and worked to establish such an organization. The couple had four children. Mettler was working on furthering his education as a paramedic and was forty pages ahead of his class in the emergency training workbook. Likewise, Duane Dress was married and a father of five and was active in both EMS training and the village council. Michael Sweeney, only twenty-one, was a lifelong resident of Put-in-Bay and a dedicated paramedic. Rigoni, an experienced pilot for Island Airlines, never hesitated when his friend Mettler called and asked for aid in the emergency unfolding.

At 9:45 p.m., the fire chief watched as the plane cleared Perry's Monument, nearly 350 feet high. This was a good sign. Likewise, Rigoni was a respected pilot who paid attention to flying conditions.

The seven-mile trip to Kelley's Island by air generally is a two- to three-minute skip. Skies were mildly clear that night, so as Rigoni noticed ahead of the plane a white foggy mass, he assumed it was a cloud that they could fly under and quickly pass by. But this mass proved not to be a cloud but a fast-moving, undetected fog bank. Rigoni radioed at once, "Medic base, be advised we're flying at zero zero." After that, the radio became deathly silent.

Investigators believe that after the call, Rigoni tried to descend below the white foggy mass, believing it was a cloud. However, the fog was a wall, and

the descent took the plane and its four passengers down into the dark frigid lake. No one heard or saw the crash.

Around 10:00 p.m., the fire chief received a call from Kelley's Island to inquire about the overdue plane. With a sinking heart, the fire chief knew that something had gone horribly wrong. A search was set into motion almost immediately, and according to the *Toledo Blade*, "friend went looking for friend."

For four days, hundreds searched for the missing plane by both boat and aircraft. The weather was of no help, producing gale-force winds and monstrous waves. Local islanders took their boats from winter storage in attempts to find the plane and, more importantly, the missing men.

Finally, an aircrew spotted an oil slick about two and a half miles from Put-in-Bay. It was determined that this was the crash site, and the plane was under the oil spill. Dale Burris, a friend of the missing, stated that upon arriving at the site, "you know in the back of your mind there's no way anyone can survive that long in the water, but you keep thinking if they had hold of something, there's just a million to one shot. You would sure want someone out there looking for you. I figured that's the least we could do, keep looking."

Grimly, Dale's hopes, with thousands of others, were dashed. The bodies of the four men were found not far from the plane. The men had tried to swim for shore but died from hypothermia in the forty-degree water.

On December 18, mourners turned up by the thousands to honor the deceased heroes. Again the weather acted up, and ferries could not transport funeral-goers to the island. Once again, aircraft was used to deliver passengers to South Bass Island. Hundreds of attendees, including other EMS personnel, came to mourn their comrades. Many were family, including wives and young children.

The island reverend, John Sherbno, spoke to the huge crowd, insisting that the tragedy "is a new chapter in the life of the island. It is indeed a tragic chapter, but it is a chapter of nobleness of purpose and commitment to others. So I ask you grandparents of today and you grandparents of tomorrow to retail [*sic*] this story. Let it become not only part of the history of these islands, but weave it into the lore and magic that surrounds them."

Meanwhile, Norby McKillips rested in intensive care. After the original dispatched plane did not come to Kelley's Island, a helicopter from Cleveland flew out to transport the heart attack victim. Strangely, when Norby's family reported the tragedy to him, the heart attack victim argued vehemently that the four men had been there to rescue and comfort him

Bell monument dedicated to the heroes who died in the plane crash. *Courtesy of waymarkers.com.*

the night of his heart attack. A month later, the police chief passed away in Good Samaritan Hospital of Sandusky. Up to his dying day, Norby insisted that all four plane crash victims had stood around him while he waited for the Cleveland helicopter to arrive. Yet the rescue plane would have already crashed at that time.

With this harrowing tragedy came a lesson. An island such as Kelley's Island with nearly six hundred locals and thousands of summer tourists needs to have an emergency medical plan established. By the mid-1980s, the new Kelley's Island police chief was offered full tuition to attend EMT refresher courses. Likewise, eight others volunteered to attend the courses and become certified or recertified as emergency medical technicians. By 1989, with the addition of local Jack Wade, Kelley's Island had a fully functioning and very knowledgeable team. Many of the original EMTs still serve the island today, nearly thirty years later. Norby McKillips, the Put-in-Bay rescue team and the volunteers of yesterday and today will be remembered as heroes of the Lake Erie islands.

Chapter 11
Middle Bass Island

The Collapse of an Era

Success is not final, failure is not fatal: it is the courage to continue that counts.
—*Winston Churchill*

Gliding across the water between South Bass Island and Middle Bass Island, lake voyagers find their eyes drawn to the abandoned yet hauntingly beautiful edifice guarding the southern shore of Middle Bass Island. The structure, with its castle-like walls, struggles against the encroaching tree branches and braces against whispers concerning a terrible tragedy that make their way to shore and seem to creep just inside the old winery. Yet even with its darker history, now and forever attached, a memory of happier times, of celebrations and merriment, of hard work and family traditions remains just within reach.

Some thirty years before Lonz Winery was forever associated with tragedy, an elderly man could be found most summer days sitting on one of the many patios of the building. Oftentimes, he was found playing his violin and gazing upon the shore. Then in his eighties, George Lonz knew that his days were numbered, yet he could hardly bear to let go of the place that he had spent his entire life perfecting.

For as long as he could remember, George Lonz had played and later worked in the vineyards at Middle Bass Island. George's father, Peter, had established his own small winery on Middle Bass after working five years at Wehrle's Golden Eagle Wine Cellars. As early as age two, George could be found toddling about the winery, curiously watching the sweet grapes turned into a liquid and bottled up for tourists to eagerly buy.

In 1922, after earning a business as well as a chemistry degree and some time spent working within Ohio's government, George, with his wife, returned to his homeland of Middle Bass Island. The following year, a fire destroyed Wehrle's Dance Pavilion attached to his winery. This proved to be a great opportunity for George. He quickly offered to buy the building and adjoining property, and his offer was accepted. Now with his father's winery and his new real estate, George began work to create the largest and most successful winery of the Lake Erie islands.

Many factors contributed to the success of Lonz Winery. First, the winery was positioned in one of the most beautiful locations of all Ohio. Many considered the island atmosphere and the castle-like building a direct replica of the Italian country wineries. Secondly, George used his skills as a chemist to create and perfect his own specialty wines. The grapes growing plentifully throughout his vineyards aided in the unique tastes of his wines. Thirdly, George had a knack for business. He was recognized on the island as a go-getter who would not settle for anything but the best. In fact, many referred to the businessman as "King George" due to his no-nonsense methods. Lastly, and most influential, George had a love for the winery business that propelled his success like no other factor. Therefore, when the king was met with a succession of setbacks over the first two decades of ownership, he was not deterred.

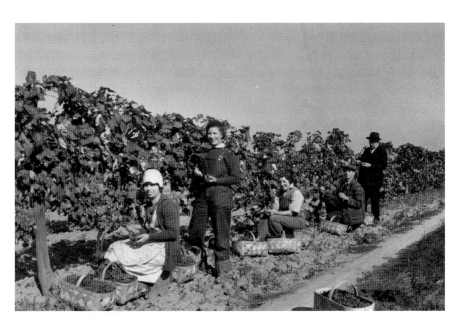

Lonz Vinyard in 1936. *Courtesy of the Ottawa Historical Museum.*

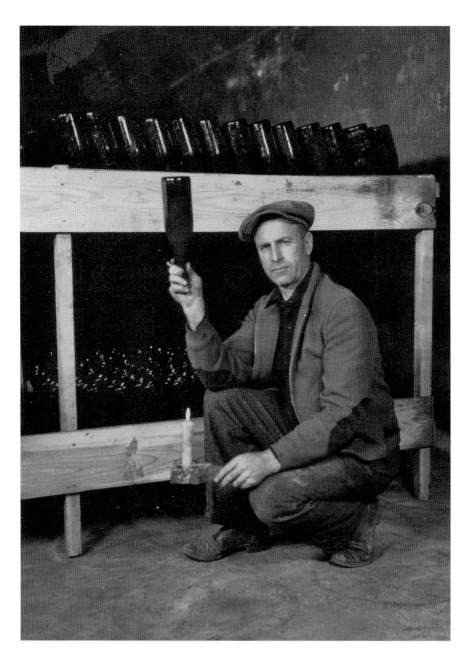

The first issue to arise for not only George, but for all island wineries, was a little issue known as Prohibition. In 1920, the Eighteenth Amendment was set in place declaring it illegal to produce, transport and sell alcohol. For many island businesses, this was a slam from which they could not recover. Yet the

Above: Wine cases were loaded onto wagons and pulled to docks for transport. *Courtesy of the Ottawa Historical Museum.*

Opposite: George Lonz visiting his wine cellar, 1936. *Courtesy of the Ottawa Historical Museum.*

innovative George experimented in his cellars in order to save his business. With his education in chemistry and knowledge of the sweet grapes, George produced a refreshing and sweet grape juice. In turn, consumers bought the locally made liquid by the gallon. Included in purchase were instructions on how to make "wine vinegar" at home, for those so inclined. Of course, the grape juice was a main ingredient to make the homemade vinegar. Sales of Lonz Grape Juice soared during the Prohibition years, keeping the business afloat.

In 1933, when the amendment was repealed, George began a massive remodeling project. The following summer session commenced the most prosperous decade in the winery's history. Additions—including a beautiful wine serving room, expansion of the already spacious wine cellars and patios—were added during this thriving era. In 1940, a huge ornamental dock was built in front of the winery. The dock was capable of anchoring ten steamers at once. However, in the height of success, another setback occurred that would have been the ruin of many business ventures.

One afternoon in January 1942, while away on business in Chicago, George received an urgent call. Apparently, the winery had caught fire.

Employees sampling grapes, 1936. *Courtesy of the Ottawa Historical Museum.*

George was needed on the island immediately. He quickly booked a plane, the only island transportation in the winter, and made the flight to Middle Bass.

Apparently, the fire was noticed by the winery secretary who lived nearby. She reported the fire at 1:30 a.m. after seeing flames in the offices and near the wine serving room. Firemen quickly formed a bucket brigade. Nearby, Put-in-Bay firemen attempted to cross the ice with their equipment but realized the ice was too weak. Many firemen braved the ice and walked on foot from Put-in-Bay to assist. All firemen, and even local citizens, worked throughout the night to put out the fire.

George estimated the loss to be between $65,000 and $70,000, with about half being covered by insurance. He was particularly concerned with the loss of numerous documents pertaining to his new business with Wisconsin to run his Erie Isle Ferry to the Lake Erie islands. These

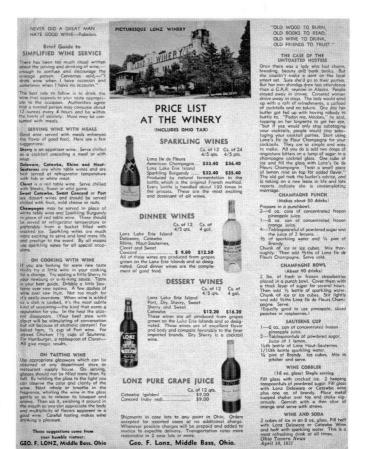

Lonz Winery wine list, 1950s. *Courtesy of the Ottawa Historical Museum.*

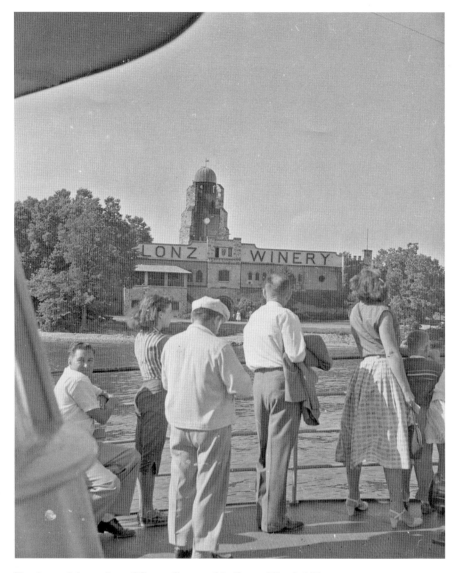

Tourists arriving at Lonz Winery. *Courtesy of the Ottawa Historical Museum.*

documents were reduced to ash inside the fireproof vault. All wooden structures within reach of the fire were destroyed as well. Likewise, nearly five thousand gallons of wine and two thousand gallons of brandy were decimated. Luckily, the latest pressed and casked wine was able to be saved.

Nevertheless, George was determined to continue on in his success as a professional winemaker and merchant. He once again refurbished the interior of the winery. Traveling the world, George continued to learn more about the winemaking industry, perfecting his own wines as he went. Notably, Lonz's wines won not only local awards but also awards abroad in both France and Italy. In the two decades after the fire, George experienced much success and enjoyment.

In the 1960s, George knew that he was beginning to slow down. Although in good health, he was now in his late seventies. It was time to consider the future of his beloved winery. With no descendants to pass the family business to, George initiated the procedures of selling the winery to the right owner. Fliers were sent out for the sale of the winery, advertising not only the lucrative business opportunity but also the fact that Gorge Lonz himself wished to train the new owner. Unfortunately, George passed away in 1969 without ever finding a suitable buyer. The winery was turned over to a group known as the Lonz Foundation.

Over the next thirty years, the business changed ownership numerous times, always keeping the Lonz reputable name. The winery was still a favorite among tourists with its breathtaking views and charming atmosphere. Most tourists who arrived at Middle Bass Island came for the sole purpose of visiting the winery. On the Fourth of July weekend of 2000, the winery was packed with nearly one thousand people chatting and laughing the lazy day away, never knowing that their lives would be changed forever that afternoon.

One survivor later reported that he remembers sitting at his table on the terrace with his friends enjoying the warm summer day. Within an instant, he explained that everything suddenly went black and he was overcome with a falling sensation. In the next few minutes, he realized that he was lying in a debris-filled hole in the earth with the sounds of shrieks and screams saturating the air. As he looked up through the smoky, dusty air, he could make out patches of the clear blue sky far above him. The moment was inconceivable and surreal. Many believed they had just experienced a very strong earthquake.

The scene that the survivor remembers is the moment when the Lonz Winery terrace floor collapsed, crushing its way through the deep wine cellars. The terrace, which was twenty-five by twenty feet, had a four-inch-thick cement floor. On the day of the collapse, approximately one hundred customers were happily sipping wine on that deck. Other wine samplers, an estimated one thousand, were inside the tasting rooms or out on the spacious grounds enjoying the views when the tragedy occurred.

As realization set in, almost everybody in the vicinity rushed to help anyone in the nearly twenty-foot-deep hole on the west side of the winery. As bystanders, and soon medical personnel, descended into the opening, they were met with a horrific scene. Victims cried out from under the rubble as workers quickly lifted the heavy cement chunks, furniture and glass from atop the wounded. One by one, blood-soaked people, some with bones poking out, were lifted from the area. When medical equipment ran low, doors were used to transport victims up and out of the scene. Eight helicopters from nearby islands and towns dispatched to Middle Bass and carried people to local hospitals.

Later, it was determined that the floor gave way due to a structural problem. The concrete terrace had been added in 1950 and was supported by thick steel beams. Over the years, it was not inspected, as it was not required by the county or the state to do so. Originally, people assumed that the terrace was overloaded, but this was not the case. It was an accident waiting to happen.

All in all, seventy-five people were physically injured, and one young man died at the scene. The horror of that continues to live on not only for the people who experienced the fall but also for witnesses of the accident. Survivors report that to this day, they are aware of any type of shaking motion while walking across a floor. Some have permanent injuries from the collapse that will never heal. And one mother has a broken heart that will never heal with the loss of her son.

The winery was closed indefinitely after the accident. Eventually, the State of Ohio purchased the grounds but made no attempt to develop the 125 acres of ground or the iconic building. Finally, fourteen years after the accident, $6 million was appropriated to Middle Bass Island for the Lonz Winery property. Plans as to what developers will do with the property have not been revealed.

Perhaps one day, the tragedy-stricken area will once again experience music, laughter and natural beauty for tourists and locals to enjoy. The place that George Lonz once loved so dearly may one day return to the most beloved winery in all Ohio. For now, Middle Bass Island visitors enjoy quiet restaurant dinning, small shops and natural beauty.

Chapter 12
Gibraltar Island

The Castle

Where we love is home—home that our feet may leave, but not our hearts.
—Oliver Wendell Holmes

After years of handling rich men's money in his Philadelphia bank, Jay Cooke found himself as one of the nation's wealthiest men during the American Civil War. With his newfound prosperity, Jay pondered what to do first. Overlooking the crowded city streets from his banker's office, Jay thought back to his growing-up years. An image of blue water dotted with the wonders of tiny green islands seen from the shore of his hometown of Sandusky filled his mind. Yes, Jay knew exactly what he should do first. For all he had to do was follow his heart.

As a young boy, Jay learned to value three aspects of life more than any other. The first was hard work ethic. His father, Eleutheros, was one of Ohio's first lawyers and was extremely active in politics. Secondly, Jay learned to appreciate family time. Many of his boyhood memories consisted of picnics on the Lake Erie islands and camping and fishing on warm summer days with his entire family. Thirdly, Jay grew up with a Christian foundation based on the love of God's creation and kindness to humankind. So when Jay entered young adulthood, these instilled values prevailed in his life.

Jay had always leaned toward a career in business. At age ten, he worked for a small income in his uncle's store in Sandusky. With his savings, he purchased a stock of toys and children's books and had his own account with the store. He loved to work with numbers and soon taught himself

Jay Cooke's Castle in 1875. *Courtesy of the Sandusky Library Follett House Museum Archives.*

bookkeeping. In 1837, he entered his first business venture in St. Louis. Although the young man and his partner failed at their merchant business, Jay learned much about business politics. So the next year, when asked to join and work for his father's business and banking connection in Philadelphia, Jay jumped at the chance to spread his wings. Over the next few years, Jay learned and perfected the banking business. With his love for numbers and hard work ethic, Jay opened Jay Cooke and Company Bank of Philadelphia, which was considered one of the largest and most powerful banking systems at the time.

As Jay enjoyed the social and business life of the big city, his mind often returned to his hometown of Sandusky. Oftentimes, he went home to visit his parents, especially in the summer. Sometimes, he would stop over in Meadville, Pennsylvania, to visit his brother at Allegheny College. It was on one of these trips that the young, handsome hotshot was sidetracked. In 1843, Dorothea Allen was also visiting her brother, and president of the college, at the same time. Later, Jay would write in his journal, "I lost my heart the first day and the second day we were sworn friends and life-long lovers." The same year, the two were married, and Dorothea moved to Philadelphia.

In the meantime, the country was in the midst of the bloodiest and costliest war of its history. Jay, with his business intelligence and connections through his father, initiated a plan to maintain the economy in the Northern states.

The Jay Cooke and Company Bank began selling war bonds. Not only was he able to coax the wealthiest into purchasing the bonds, but he was also able to market to the common man. This system is believed to have saved the Union economy from total collapse. Thus, Jay Cooke is often considered the man who financed the Civil War.

Yet even with all his riches, Jay yearned for something more. The memories of his childhood, the peace with nature and God and the time spent with family had lived in his heart throughout the years. So the "richest man in the nation" returned to his hometown with his wife and young children. In 1864, Jay purchased his very own Lake Erie island for $3,001 and had a summer mansion constructed on the east shore.

Gibraltar Island sits just west of Put-in-Bay. Named after Spain's Gibraltar, the island's rocky terrain reminded early settlers of the gateway to the Mediterranean. It is believed that Oliver Perry oftentimes used this island as a lookout for enemy ships. The area, with its rugged cliffs yet sandy shoreline and grassy nooks and crannies, was perfect for the Cooks to relax and explore. The children were free to roam about the six and a half acres of private property.

Most impressive, however, was what many referred to as "Cooke's Castle." Built in 1864, the home was situated on the highest portion of the island. Its Victorian Gothic and grandiose style earned it the nickname. The fifteen-room mansion was constructed from only the finest materials, which were shipped out to the island. Several of the windows were salvaged from the half-sunken *Island Queen* steamer that was hijacked by Rebels during the Civil War. Jay's favorite portion of the house was the four-story, seven-sided turret that housed his library.

For years, the family vacationed on the island. Oftentimes, the entire castle was filled with guests, some important dignitaries, while many were church families from the smaller parsonages of the Sandusky area. Either way, guests were treated to all-inclusive accommodations, including travel, food and lodging, and were always waited on by a friendly full-time staff.

Even with his riches and lavish lifestyle, Jay Cooke never lost sight of his faith. In later years, he wrote in his journal, "Many years from now when we old ones are all gone, I suppose my children and grand and great grandchildren will read these records with curiosity and interest—let them all understand that this dear Gibraltar was the gift of God to me and I receive it as such and enjoy it as such." Perhaps Jay's deep beliefs are what kept him afloat during one of the most disastrous periods of his life, as well as the country's economic life.

Another view of the castle, 1875. *Courtesy of the Sandusky Library Follett House Museum Archives.*

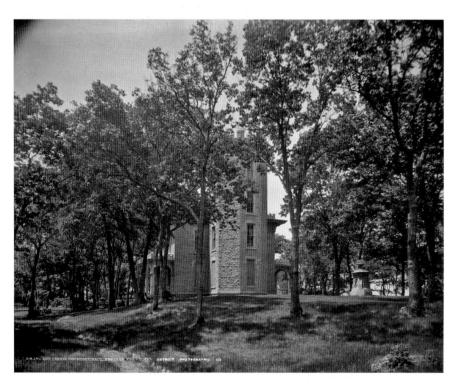

Side view and yard of the castle, 1875. *Courtesy of the Sandusky Library Follett House Museum Archives.*

After the Civil War, Jay continued managing his bank. Always one step ahead on business trends, Jay hopped aboard railway ventures. From his early days in St. Louis, he had developed a love for the old steam engines he watched pulling into and out of the station. So when talk of a new railroad began, Jay's interest was piqued. Selling $300 million in shares to local and overseas investors, Jay financed the Northern Pacific Railroad as it broke ground in Duluth, Minnesota, in plans of constructing the second transcontinental railway. However, as the first lines of the rail were put down, the stock market began to quickly crumble. Sadly, the man who had largely financed the American Civil War found his company in a financial emergency. In 1873, Jay Cooke and Company filed bankruptcy. When news was out, crowds stormed the banks in order to pull their own money out for fear of losing it all. This, in turn, was followed by several other banks in the nation collapsing. The Panic of 1873 would lead the country into a six-year depression.

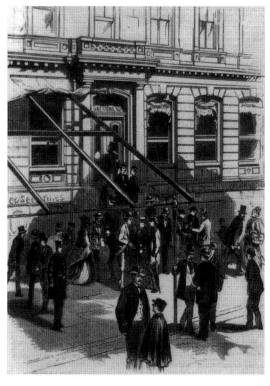

An illustration depicting the Panic of 1873. *Courtesy of the Library of Congress Digital Collections.*

Heartbreakingly, Jay was forced to sell his beloved island and mansion. The island was purchased, yet a buyer for the home could not be found due to the expense. The shame of his failed business, the selling of his heaven-on-earth home and the dire situation of the entire nation was devastating to Jay, to say the least. Additionally, Dorothea, Jay's brother and Jay's parents had passed away over these already miserable years. Yet with his ever-present faith and steadfastness, Jay did not give up on life completely.

Many politicians and business tycoons still sought advice from one of America's most successful bankers. As the money market crashed around

Portrait of Jay Cooke in 1874. *Courtesy of the Sandusky Library Follett House Museum Archives.*

them, Jay advised his investors to not sell their shares in the railroad, but to be patient. In the meantime, Jay used his meager salary to invest in the silver mines in Utah. In 1879, when the market finally turned for the better, his well-advised clients found themselves very wealthy people. And his investments in Utah proved to be profitable for Jay. He was able to repay all debts. Thus, Jay's good name was restored as well as his wealth.

An older man now, Jay returned to the one place he wished to spend his sunset years. He quietly bought back his island and mansion and reemployed most of his former staff. In 1879, on a warm summer morning, Jay and his adult children rode out to the island. To their surprise, the staff waved and cheered from the shoreline. They had cleaned the mansion from top to bottom in preparation for the family's homecoming. Before his death in 1905, Jay often wrote about returning to his refuge, Gibraltar Island, where he was free to relive happy days. He was able to travel to the island one last time in 1905, four months before his death. The island and home remained in the Cooke family until 1925.

Cooke's Castle can still be visited today. Although no tours are offered on the inside due to safety issues, tourists are treated to stunning architectural photo opportunities from the outside. The entire island is now owned by The Ohio State University, and college students spend time at the Stone Laboratory researching Lake Erie's flora and wildlife. College students often mention their once-in-a-lifetime experience on the island. They, too, have come to appreciate this tiny dot of land that Jay Cooke described as a "foretaste" of heaven. Cooke's Castle sitting high on the island attests to Jay's faith, hard work and perseverance.

Lost Legends and Their Islands

Mere dots as they are on the broad bosom of an inland sea, the reminiscent lore attaching to the smaller islets dating from their earlier history is interesting.
—*Theresa Thorndale, 1892*

MOUSE ISLAND

Named for its very small size, Mouse Island is one of the smallest of all the Lake Erie islands. A nineteenth-century explorer described the island as "a very small affair, so small one might someday take a fancy to pick it up, slip it in his vest pocket as he would a watch, and slip off with it." This tiny gem sits just a fourth of a mile off the tip of Catawba Island and can be viewed from the shore. About five acres in size, the little islet has always been privately owned and is generally off-limits to the public.

In 1874, the Lake Erie and Louisville Railroad purchased the small piece of land with business in mind. The company sought a shipping port where its train cargo could be unloaded and then reloaded onto a Great Lake ship. Soon, the company realized there was a slight problem with this idea.

The water near Mouse Island is quite shallow. In fact, a limestone reef lies just under the waterline between Mouse Island and Catawba Island. Therefore, to ship heavy cargo across this stretch of the lake was nearly impossible. Likewise, the huge ships coming in from the open water were

wary of running aground in this particular port. Consequently, the railroad was ready to sell this piece of land that was of no use to it.

In the late 1870s, a very interesting buyer inquired of the island. President Rutherford B. Hayes wished to purchase Mouse Island as a relaxing retreat from his considerably stressful job of running the entire country. Perhaps President Hayes knew of the island as his family home was just twenty-six miles south in Fremont, Ohio. So when such a unique section of land came onto the market, the president jumped at the chance to purchase it. Paying $30,000, the president purchased his very own island.

For years, the Hayes family enjoyed their slice of Lake Erie. They built a moderate family lodge, as well as two guest cabins, a tennis court, a boathouse and a dock. The family also had running water and electricity established on their land. Nicknamed the "Summer White House," Mouse Island proved to be a relaxing and tranquil getaway for the president and his family. Lazy days were spent bird-watching, swimming, taking photographs and entertaining many guests. The Hayes descendants continued the summer tradition until the 1930s, when the grandchildren lost interest in the island. For the next thirty years, the property and island sat abandoned and in disrepair.

In 1966, Rutherford's great-grandchildren decided to sell the property. The two-acre property was sold to a local buyer for $16,500. Since then, the property has changed hands numerous times, and it is currently privately

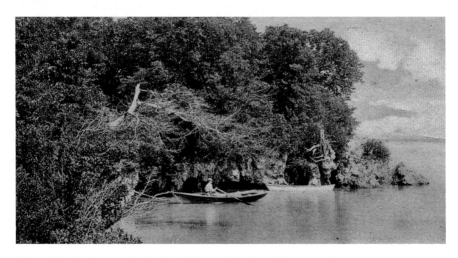

Mouse Island. *Courtesy of the Sandusky Library Follett House Museum Archives.*

owned and off-limits to the public. The trees and vegetation have once again grown up over the island. Hidden on the south shore, remnants of a vacationer's dream home can be found. An old stone hearth, a square foundation and a small tennis court are the only signs of human life on the tiny island.

STARVE ISLAND

Starve Island just off southeast Put-in-Bay is a pebbly lot less than two acres in area. Legends states that the island was so named after a sailor supposedly starved to death on the island. Years after his death, his skeletal remains were found on the tiny beach, and the legend was born.

In a similar story, occurring during the summer of 1932, a curious fisherman decided to explore the island. His friends left the man at the island and planned to return within a few hours. As is typical with Lake Erie, a violent storm unleashed its fury onto the western end of the lake, making it impossible for the fishing boat to return to Starve Island. The next morning, the coast guard was sent out to rescue the island explorer. The

Starve Island. *Courtesy of the Ottawa Historical Museum.*

Starve Island postcard. *Courtesy of the Ottawa Historical Museum.*

castaway had not starved to death during his time on the island. However, it was reported that he was found in a "nervous shock" but returned home unharmed that afternoon.

WEST SISTER ISLAND

Of the three sister islands, only West Sister lies within Ohio's boundary. Unlike the other Ohio islands, West Sister Island does not have any nearby island neighbors. In fact, its closest island is South Bass Island fifteen miles to the east. Thus, unless one enjoys complete isolation from the world, West Sister Island is not the place to go. The area is so secluded that in 1975, it was converted into a federal wilderness. Without many human interruptions over the years of settlement, wildlife claimed the eighty-two acres as home. Herons, egrets, gulls, red-winged black birds, song sparrows and warblers nest in the tall hackberry trees that stand nearly fifty feet tall. In 1983, one wildlife researcher counted over one thousand nests. Snakes of numerous varieties sun themselves on the big boulders of the island.

Although the private sanctuary may seem perfect for bird-watchers, one visitor took no pleasure in her time spent in the secluded nature of West

Sister Island. Delia Hotchkiss was the daughter of the third light keeper of West Sister Island. At age twenty, she had spent two years of her life on West Sister Island with her parents. Apparently, Delia was slowly driven mad. In June 1852, the beautiful young woman threw herself from the high cliffs of West Sister Island. The *Daily Commercial Registry* of Sandusky reported that "in her days of health and prosperity she had been a girl of cultivated mind and taste. Loss of health, reduced circumstances, and the solitary seclusion of her Island residence, induced melancholy, and in a mood of mental aberration, she wandered away unobserved, and threw herself into the Lake." Delia also left a note for her family and a small trinket as a clue to where she would end her life. The family was able to pull the young woman's body from the lake. Her burial records are lost to time, but it is believed Delia was buried away from the island, the place she came to loathe.

By 1937, the old lighthouse had been decommissioned for an automated light. This left the island totally void of humans. In 1938, the island was set aside as a national wildlife refuge. Strangely, during World War II in the 1940s, the military was granted access to use the island as a practice bomb target and shooting artillery practice. During this time, the light keeper's house was destroyed.

After the war, the island was given back solely to nature, minus the few youngsters who periodically crept about the island in search of an adventure. Over time, the birds and snakes reclaimed their space once and for all. Today, human visitors are not permitted. Boaters are welcome to view the island and wildlife from the water.

LOST BALLAST

Lost Ballast Island is a petite oval-shaped nugget separated from Ballast Island by a few yards of water. At one point, Lost Ballast was attached to Ballast Island. In the 1970s, Lost Ballast slipped under the water due to the high water levels. Today, the island reef can be spotted across the way from Ballast Island with its small crop of trees and plants.

Above: Lost Ballast Island, 1909. *Courtesy of the Ottawa Historical Museum.*

Left: A view of Lost Ballast Island in 1989. *Courtesy of the Sandusky Library Follett House Museum Archives.*

BUCKEYE ISLAND

Off the northern tip of South Bass Island, a small outcropping of trees rises from the lake. Now considered a reef by most, Buckeye Island was once home to Henry Pletscher, who seemingly lost his heart to the rocky patch of land.

After the Civil War, Henry returned to Ohio from the battlefields. Marrying his hometown sweetheart, Henry was ready to start a family. Shortly after, disaster struck the small family with the death of their two-year-old son. Henry, in his extreme grief, decided to go west in search of his long-lost brother. Two years later, he returned to his wife only to find she had remarried. Apparently, after not hearing a word from Henry, the wife assumed she was widowed. Consequently, Henry returned to the West and rejoined the military.

After an exciting career fighting on the western plains, Henry sought some peace and tranquility. Therefore, he bought himself a tiny island in Lake Erie in 1909.

As Henry's island gardens bloomed, it seemed that Henry's spirits blossomed as well. To Henry, it seemed as though he had finally found his heart. Soon he built a very small cabin, shed and dock. Family and friends were always welcome on the island. Hours were spent chatting, picking raspberries and enjoying the lake views. When the winter cold settled over the lake, Henry was invited to the mainland to stay with these same family and friends. Although warm and comfortable in his winter lodgings, it was always apparent that Henry could hardly wait to return to his little island. For over five years, Henry seemed perfectly content.

Sadly, at the age of seventy-six, Henry's heart was broken once again. He mistakenly signed papers relinquishing ownership of Buckeye Island. As realization sunk in, Henry fell into a deep depression. Moving into the Sandusky Soldiers and Sailors Home, Henry spent the rest of his life in quiet sadness. His heart, it seems, was lost with his island.

As years went by, Buckeye Island seemed to lose its vitality. Henry's cabin, dock and gardens were washed away. More and more of the island surface slipped under the lake. Trees and vegetation reclaimed the minuscule land that stayed atop the waterline. It seemed as though the island grieved for the owner who had showed such loving care.

Today, Buckeye Island, sometimes known as Buckeye Point, can be accessed by walking the isthmus from Scheef East Point Nature Park at South Bass Island.

BALLAST

The twelve-acre island of Ballast most likely was named in the belief that Commodore Oliver Hazard Perry stopped on the island's boulder-encrusted shores and took rocks to ballast his ships. Long after the hard-fought battles of Lake Erie, local people took an interest in island ownership. In 1874, Clevelander George William Gardner purchased Ballast Island from Lemuel Brown, a half-breed Erie Indian.

George Gardner seemed to be born with lake water in his blood. At age nine, he ran away from home to board and sail on one of the Lake Erie schooners. As a young man, while mayor of Cleveland, Gardner organized several canoe and yachting clubs. Once he had the keys to his new island, he quickly created a canoe club there as well. Numerous large-scale canoe races were held off the shores of Ballast. Soon, George sold lots on the island to his sailing friends from Cleveland, forming a cooperative association of wealthy families there. Eventually, nine cottages were built, as well as a hotel.

A favorite legend concerning Ballast Island was that of a hermit affectionately called Uncle Jimmy. When and why he came to the island is not certain. However, storytellers would later suggest that Jimmy came to the island long before the general public discovered it, and he did so to live a life of solitude. On the island, he inhabited a timeworn cabin; he was the only person on the island, as he preferred it to be. He did, however, enjoy the company of a dog, a cat and an old horse and cow, both of which sheltered in a dilapidated shed. When absolutely necessary, Jimmy would sometimes have to row across the passage to Put-in-Bay for supplies.

For years, the hermit enjoyed his solitude. Occasionally, he would encounter people on the island. One guest was the owner of the island, Lemuel Brown, who did not seem to mind Jimmy living there. Other times, passing fishermen would stop by to rest or fish from the shore. Anyone visiting the island in those days was surprised to find a rather chipper hermit living among the trees. Apparently, Jimmy's life of isolation was working out quite well.

As times changed on the mainland, so, too, did the life on the islands. In the late 1800s, Americans began to take an interest in peaceful getaways. Ballast, like most of the Lake Erie islands, was purchased for this type of peacefulness. Jimmy must have been quite aware and concerned about his new neighbors as George Gardner and his buyers occupied his small slice of heaven. His concerns, on the contrary, turned out to be unfounded. As it turned out, the new neighbors were welcoming of Jimmy, and soon the

old hermit began to look forward to their visits. Likewise, the new islanders found the happy-go-lucky Jimmy to be a wonderful addition to the newly formed island family.

With his newfound friendships, Jimmy apparently developed trust for outsiders. One spring afternoon, Jimmy decided he would board one of the fancy steamers carrying people to the shore of Sandusky. He had for several years watched this particular vessel maneuver between the islands, always bringing crowds safely ashore. Other than some social anxiety, the voyage promised to be a pleasant and promising excursion for a man who had lived on an island for most of his life. Jimmy and the other passengers had no inclination of the dreadful events about to unfold on that beautiful sunny day.

Between 3:30 and 4:00 p.m., locals from nearby islands heard a loud explosion coming from the vicinity of Kelley's Island. Most reasoned that it was probably related to the work at the Kelley's Island limestone quarries. But as flames shot into the air and thick smoke darkened the blue sky, people realized something was terribly amiss.

At the wharves of Sandusky, crowds gathered as news made its way to land. An island steamer had exploded near Kelley's Island, and passengers were being brought to Sandusky Bay for medical treatment. As the blackened, disfigured passengers arrived, the crowd gasped in horror. Some were deceased. Others, like Uncle Jimmy, were barely alive.

Medical workers worked throughout the night to save the patients with life-threatening burns. Sadly, no more could be done for most of them. By morning light, most of the injured passengers had died. The patient called Jimmy quietly slipped away as a priest blessed his soul with last rites.

With no known family, officials most likely planned to bury "Uncle Jimmy" in an unmarked grave. But once the Ballast Island property owners heard the news, they insisted on a proper burial. On Put-in-Bay, a small graveside service was conducted in the little cemetery. Later, a tombstone was erected, and the epitaph read, "To the memory of Uncle Jimmy of Ballast Island, erected by his friend, George W. Gardner."

Today, the island has just seven homes, only a few of which are originals from the days of George Gardner. Several of the owners today are lineal descendants of members of the first homeowners' association on Ballast Island.

RATTLESNAKE ISLAND

On a typical summer's evening, fishermen and women can be found on the many docks jutting from the islands. The discussion between the boaters is to determine who has the best catch of the day. The bragging ritual has been going on as long as fishing has been a sport. But in 1965, Jeff Bennet found he had something much more impressive to brag about concerning the catch of the day. Hubert Bennet owned Rattlesnake Island from 1929 to 1951. It was during this time that Hubert and his brother, Jeff, caught and killed a massive number of snakes on the island. Jeff told the *Put-in-Bay Gazette* in an interview in 1965, "We found we enjoyed the sport." Their hobby began on Mouse Island, where they spent much time as young men. Once that area was pretty well depleted of its snake supply, they traveled to Rattlesnake Island, assuming by the name of the island that the snake harvest would be plentiful. Hubert liked the island so much that he eventually purchased it, allowing the brothers to have free range of the reptilian-infested eighty-five acres. Jeff also pointed out that the snakes infesting the island were not rattlesnakes but, rather, various water snakes indigenous to the western portion of the lake. Regardless, the brothers bragged that they were solely responsible for controlling the snake population of Rattlesnake Island.

Whether the numbers in the snake-killing story are factual or not, what is true is that in one way or another, the island was indeed named after a snake. A map published in 1757 labels the uniquely shaped land as Rattlesnake Island. No other islands were named on the map, suggesting Rattlesnake Island had made quite an impression on someone. Historians debate whether the name came about due to the shape of the island or due to the fact that it was unusually infested with the slithering creatures. From the air, the shape of the island appears to have very distinct rattlesnake markers, as described by Teresa Thorndale in the 1890s: "In shape it is elongated with a hump in the middle and two islets—mere dots—at the tail end known as the rattlers. Viewed from a distance, a lively imagination may readily resolve the dark couchant body of land outline against the turquoise blue of Erie into a gigantic rattlesnake, with its head erect and rattles in working order." Likewise, early explorers wrote about stepping on a snake every few feet or so once on the island. In 1792, a French writer and historian noted, "The Viper Islands are covered in serpents entwined in one another. When the sun shines on them, you can distinguish nothing but sparkling eyes,

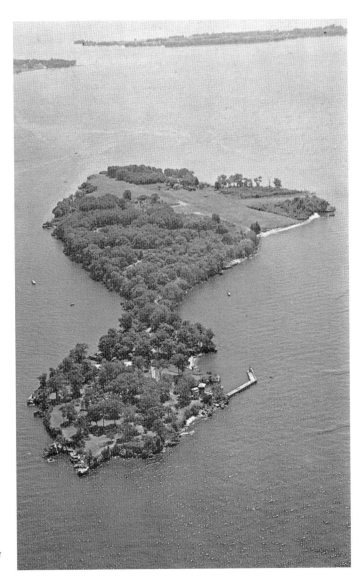

Rattlesnake Island postcard, 1969. *Courtesy of the Sandusky Library Follett House Museum Archives.*

tongues, and throats of fire." Whatever the case, the island will forever be associated with the rattlesnakes that scientists point out did inhabit the island in mass numbers at one time.

As for human inhabitants, the story really picks up about the time of the Bennet brothers in the 1930s. When the boys were not involved in hunting expeditions, Hubert began construction on the island. Owner of the Toledo Scale Company, Hubert was a businessman by nature. He recognized the

potential of his island and had a personal home, guest lodge, harbor and landing strip built to draw in the crowds from Put-in-Bay. With Hubert Bennet's visionary talents, the island known for its snake population became a destination for some of Ohio's wealthiest people.

At Hubert's death in 1951, Rattlesnake Island was sold to a Catholic order that wished to use the island as a retreat for priests. Although this did not work out as planned, the Catholic owners did add an additional airstrip. In 1959, the island was sold once again to James Frackelton, a surgeon and owner of the Cleveland Stamp and Coin Company. Dr. Frackelton's dream was to create an exquisite place for his heart patients to recover. Although this also never materialized, the doctor did have an influence on the history of the island.

In the 1950s, Dr. Frackelton petitioned the United States Postal Service for mail service directly to the island. Finally in 1966, after years of litigation, Rattlesnake Island had its first operational post service. Most interestingly, Dr. Frackelton designed a unique triangular stamp for islanders to post mail. Rattlesnake Island Local Post was in operation until 1989, when new island owners discontinued the service. The triangular vintage stamps are priceless to stamp collectors and local historians. In 2005, the post system was reestablished and continues to this day.

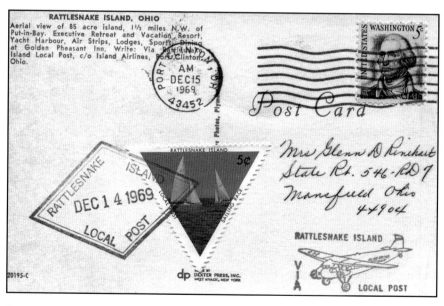

Rattlesnake Island's own postage stamp. *Courtesy of the Ottawa Historical Museum.*

In 1999, Dr. Frackelton and sixty-five other private investors purchased the island for private use. The island, its mansions and the elaborate clubhouse are now shrouded in the secrecy of a tightknit club of the elite. Rumors of parties staffed with the most beautiful European women are whispered about the area. Membership is limited to just sixty-five lucky folks who are sworn to secrecy regarding the identity of other members, club activities and all monetary matters of the Rattlesnake Island Club.

Sugar Island

Sugar Island was once attached to Middle Bass Island by an isthmus, or land bridge. Now the thirty-acre privately owned island sits unconnected near the northwest shore of Middle Bass. It is believed that once humans began cutting down trees on Middle Bass Island, the lake began to erode the isthmus until it was completely submerged. Currently, a few homes are located on the island.

Gull Island

Sailors of today are well aware of the Gull Island Shoal and the danger it poses to their water vessels. Before it became labeled as a place to look out for, the reef was an island. Nineteenth-century maps display a small island between Kelley's Island and Middle Island. Gull Island was once known as the perfect place to hunt and gather seagull eggs, as the gulls nested on the uninhabited island by the thousands. Current research suggests that the island became submerged in the mid-1800s.

Kafralu Island

For twenty-five years, Louis Wagner had a crazy notion that he could not get out of his head. During his youth, while on a return fishing voyage, Louis and his friends had run their small boat aground on an infamous sandbar adjacent to Cedar Point. While stranded on what was known as Sunken

Island Sandbar in Sandusky Bay, waiting for the waves to push them off, the men discussed what it would be like to build an island there. The men had a good laugh about their adventure and their conversation as they were set free from the hang-up. Yet for Louis, the idea seemed to resound with his soul. Over the next ten years, working as a harness maker, the idea only became stronger. As explained by Louis, "I tried to forget it, but forgetting was anything but an easy matter. The desire to own an island—and a summer home—only became stronger."

With the help of his local friends and his two strong sons, Louis began to haul huge logs and fill to the sandbar. The convoy also took numerous planks into the lake. They positioned the planks so that the waves would continuously deposit sand in the enclosures. A local basket shop in Sandusky donated plenty of shavings to be added in as well. Clay was dredged from Sandusky Bay and later added. As the tiny mound took shape, Louis named his island Kafralu Island by combining letters from the names of his wife, Katherine, and two sons, Frank and Louis.

Once Kafralu was complete after six years of perseverance, Louis added a small cottage for his family to enjoy. Riding on the high of successfully constructing his own island, Louis built several additional cabins and used them as rentals. A total of twelve cottages, a dock and a Kafralu fishing rental boat made up the island empire. For a time, Kafralu Island was a busy little vacationing area in the summer. Next to Cedar Point Amusement Park and in line with the big islands, Kafralu Island offered everything in the way of Ohio's Vacationland.

Excitingly, in 1938, a monkey escaped from Cedar Point and made its way to Kafralu Island. For weeks, Louis fed the creature bananas and grapes in order to coax it out of hiding. He placed the treats on the roof of his cabin to make it more comfortable for the little fellow. Eventually, the monkey was caught by Cedar Point officials and sent to a home in Florida.

In 1941, Louis Wagner passed away, and his island sat nearly vacant due to the war. In 1946, several of the cottages burned to the ground. Shortly thereafter, the family sold the man-made island to Cedar Point for development.

Chapter 14

Island Lights

Darkness reigns at the foot of a lighthouse.
—Japanese proverb

SOUTH BASS ISLAND LIGHTHOUSE

After a three-year stint in the U.S. Navy and time spent as a wheelman and second mate aboard the USS *Haze*, a lighthouse tender ship, Harry Riley was ready to use his land legs. So when the forty-five-foot-tall lighthouse with a massive two-and-a-half-story attached dwelling house was built on the popular resort island of South Bass, Harry quickly applied for the job of lighthouse keeper. With his maritime experience, Harry was hired for $560 per year to keep the light. In 1897, Harry, with his bride at his side, took guard as South Bass Island's first light keeper.

Notably, the dwelling house was furnished with every modern convenience of the time. This was unheard of for most other light stations. Included in the lodging arrangement were spacious living quarters with huge windows overlooking the lake, gold-tinted wallpaper and gilded moldings, lavish carpets, expensive furniture, a huge cooking range with a hot-water reservoir, a laundry room, a furnace and a cistern. With Harry's love of the water and with a new bride, the situation must have seemed perfect. Unfortunately, darkness loomed just around the corner.

South Bass Island and cliffs. *From Wikimedia Commons.*

Although there were no huge calamities during Harry's first season, the job was quite the undertaking. In the 1890s, South Bass Island, also known as Put-in-Bay, was quickly becoming a favorite resort for many, especially with the newly constructed Hotel Victory on the island. Between leisure boating, ferries and ships, Harry was extremely busy keeping a lookout over the lake in the South Passage area. Therefore, in 1898, a fellow by the name of Samuel Anderson was hired as assistant light keeper.

This setup worked rather well for Samuel. Not only was he hired as part-time assistant, but he also worked as part of the staff at the Hotel Victory. Eventually, Samuel took up residence in the basement of the lighthouse. This, too, worked out great for Samuel, for he could concentrate on his real passion in life: collecting and studying snakes indigenous to the island. Sure, sometimes people stared at Samuel while he transported the creatures across the island. But once behind the cool, dark basement walls, Samuel could thoroughly enjoy the beauty of the reptiles.

Meanwhile, Harry was aware of his assistant and his eccentric ways. Nevertheless, Harry was fond of the young fellow and let him have his privacy, just so long as the Mrs. did not learn of the nonhuman guests living in the place. After all, Samuel was a great worker, and it was nice to have another fellow around during the slow hours. The bond between the two was most likely strengthened during those long days.

As a light keeper, Harry was trained to keep an eye toward the expansive and temperamental lake. How could he know that the real trouble was occurring just steps from his own back door?

In late August 1898, a story broke in the national newspapers concerning a smallpox outbreak among servants at Hotel Victory on South Bass Island. Within two days of the publication, the island was quarantined, although a "massive exodus" occurred before the story broke. With this much panic to return to the mainland, the lighthouse keeper was on full alert of boat traffic. Therefore, Harry did not notice when his assistant quietly and quickly lost his sanity.

In all the panic of the smallpox epidemic, Samuel, a very antisocial person by nature, became overcome with fear of contacting the disease. It is rumored that Samuel locked himself in the sanctuary of the basement for several days in order to escape the deadly disease. During his own personal quarantine, Samuel must have come to the conclusion that there was only one way to escape such a horrid disease.

One quiet afternoon, Samuel gave one last glance to his prized snakes and noiselessly emerged from the basement. Quickly now, he made his way to the high and rugged cliffs at the shore of the lake. With one quick glance at the light tower, Samuel plunged to his death thirty feet below.

When Harry learned of his assistant's death is not quite known. However, it is plausible he may have had to assist in rescue efforts. Whatever the case, the death of Samuel was traumatic for Harry. Within two days after the event, Harry was found wandering the streets of Sandusky in an "insane state of mind."

Apparently, the respected light keeper was found proclaiming news of his racing horse. He even invited the townspeople to come and watch the horse race at the fairgrounds. Sadly, it was soon discovered that no such horse or race ever existed. Officials of the area concluded that Harry Riley was "hopelessly insane," and he was taken to the insane asylum in nearby Toledo. Not even a year later, the once vibrant naval officer, sailor and light keeper died within the walls of the hospital.

In 1904, an article appeared in an Ohio magazine detailing the situation concerning the light keeper and his assistant. According to island legend, it was believed that Harry might have known more about the death of Samuel Anderson than was previously believed. Perhaps Harry could have been at fault. However, Samuel's death was ruled a suicide by the lighthouse board, and the rumors eventually died down.

Over the next sixty years, ten different light keepers and their families took up post at the South Bass Island lighthouse. In an ironic turn of

South Bass Island Lighthouse. *Courtesy of the Ottawa Historical Museum.*

events, the fourth light keeper, Charles Duggan, fell from the cliffs and died in 1925.

In 1962, an automated steel structured light was constructed to do the job of lighting the way to and from the island. In that same year, the lighthouse and dwelling were turned over to United States Department of Health, Education and Welfare. Eventually, Ohio State researchers from nearby Gibraltar Island noticed the vacated buildings and petitioned for ownership. In 1967, the property and buildings were deeded to The Ohio State University. In 1997, one hundred years after the lighthouse's construction, the university fully acquired ownership of the light. In recent years, the university has begun tours of the lovely lighthouse perched over the cliffs of Lake Erie.

For some, the story of the first keeper and his assistant cannot be forgotten. It is believed that the lighthouse, especially the basement, is unquestionably haunted. Whether it is Harry and his sorrow or perhaps Samuel still in his paranoid hiding, ghostly noises are heard frequently in the lighthouse.

TOLEDO HARBOR LIGHT

Joseph Bernor sat near the south-facing window on the second floor of the Toledo Harbor Lighthouse, a crib light positioned at the entrance of Toledo Harbor. He was neither sleeping nor really awake. For days, he had paced the floor, unable to calm down. Sleep, which may have been the only escape from this mess, had eluded him. Yet as he sat in the tiny ray of sunshine coming through the ice-encrusted window, his head gently fell toward his chest and his body began to give in to the darkness of sleep. Just at that moment, a tremendous crash sounded below. With a jerk, Joseph was fully awake and ready for the inevitable. Whether it be the lighthouse caving in around him or, even worse, the corpse in the bedroom below marching up the stairs, Joseph stood at full attention, awaiting his fate. He would later write of his time in the lighthouse, "There was an atmosphere of death...wherever I went I seemed unable to escape from the haunting sense of its presence." In the moment of the violent crash that shook the entire lighthouse, Joseph wondered if he, too, would become part of the haunting deathly presence within the walls of the light.

A week before that miserable day, Joseph, a young man in his twenties, had happily agreed to accompany one of his favorite cousins, Captain Delos Hayden, to the Toledo Harbor Light. Captain Hayden, a seasoned keeper of Lake Erie lights, was serving as the first Toledo Harbor Light keeper in 1908. This marked his fifth year as keeper, although he had been keeper of the West Sister Light for thirteen years prior. So in February, when Captain Hayden announced a trek to the harbor light, Joseph hopped aboard in anticipation of a few quiet weeks spent listening to the many adventurous tales of his admirable cousin, now an old man.

One of Joseph's favorite stories told by cousin Delos occurred in February 1899. While serving as light keeper of the West Sister Lighthouse, Delos and his assistant, William Brown, started out for the mainland in an open boat. Just like the current lake conditions of 1908, the ice was frozen in island-like chunks, leaving small paths to navigate through the passage. However, the pair had only gone a short distance when their boat became wedged between the ice floes. For hours, the light keepers sat huddled against the frigid air until at last both slipped into a frozen unconsciousness—the final stage before freezing to death. Around the same time, two ice fishermen nearby spotted the small boat and came to assist, as it was obviously in trouble. When the two light keepers were brought to shore, William was already dead. The crowd gathered on shore feared that Delos was just moments away from his

death as well. Miraculously, several weeks later, Delos returned to his post at the lighthouse, ready for duty.

As Delos and Joseph placed their own boat into the icy, slushy lake, Joseph wondered if his cousin thought back to that near-death adventure. If he did, Delos gave no indication of fear as the cousins started the thirteen-mile journey to the light.

But just as in the adventure story years before, the small boat caught against the ice floes. The lake current, moving rather quickly, dragged the ice and anything in or on it in whichever direction it pleased. The men fought against the movement, inching along for nearly two days. When they finally reached the harbor light, both men were exhausted and nearly frozen. The boat was a complete loss.

Quickly, Joseph made a fire and tended to Delos. The old man had taken a severe cough and was complaining of chest pains. For two days, Joseph tended his cousin until at last Delos seemed to take a turn for the better, even eating some soup. Sadly, this strength soon diminished, and while Joseph held his cousin in his lap, the old captain slipped away.

After several hours grieving his cousin, Joseph knew it was time to let go. Delos had died in his bedroom on the first floor. Joseph opened several windows on the floor in order to preserve the body for a proper burial. With one last look at Delos's kind face, Joseph ascended to the upper levels of the lighthouse in order to gauge lake conditions.

As expected, the lake was near frozen, with open icy water in every direction. The only method of travel at this point was to swim, which would surely be met with death. His only option, then, was to wait it out. With any luck, a fishing vessel would come by and help escort Joseph and his deceased cousin to shore.

But as one day turned into two, and two into three, Joseph realized that no such event would occur. In the eerie quietness that enveloped him on all sides, Joseph could not control the loud panic beginning in his mind. Time and time again, his thoughts returned to the corpse lying just one floor below. Later, when retelling the morbid tale, Joseph would say, "Always in the silence of night, my thoughts kept recurring to that motionless figure on the first floor, until I began to think I would go mad unless I escaped." He would also explain that even with extreme sleep deprivation, his senses were acutely alive and always listening for even the slightest creak from below. Thus, when a horrific crash did sound on the sixth afternoon, Joseph sprang into action.

With no appearance of a walking corpse and the lighthouse still intact, Joseph attempted to find the cause of such a noise. As he peered out the

windows, he realized that while dozing, huge ice floes had drifted into the harbor and rammed into the lighthouse. This was his only chance!

Quickly, he pulled on his boots and coat and lowered himself by the ladder connected to the lighthouse. He stepped onto the nearest ice floe and began his treacherous journey toward the mainland. His plan was to walk toward the west in hopes of reaching Bay Point or Gard Island on the Michigan shore. With a small compass in hand, Joseph leapt from chunk to chunk in a westward fashion, more often than not slipping into air pockets and sinking in water up to his knees.

Just as he began to make progress, however, wet snowflakes began to cover his compass. Soon, a blinding snowstorm was upon him. With each gust of wind, Joseph fought the urge to lie down on one of the floes and give up the fight. But he knew that he had come too far, and he was not going to go out like this. With every ounce of strength, Joseph pushed through the night. Finally, near five o'clock that evening, he found an ice fishing shanty. Inside, the fisherman and his wife quickly offered Joseph food and shelter for the night.

The next morning, Joseph returned to the ice fields where he continued his journey. Soon he saw the gray line of land just within reach. As he neared the shore, he broke through the ice one last time, splashing in water to his chest. Joseph pushed his legs on until at last he stood on a beach near the town of Ironton. To his utter disbelief, he had landed near Cedar Point. This was the complete opposite shore of his intended destination. No matter; on shore, he was able to quickly secure help and medical attention.

When news of the death of Captain Hayden reached Toledo, a rescue party went to retrieve the body of their light keeper. The story of Joseph Bernor, his time in the lighthouse and his journey across the lake would later appear in a famous European magazine that advertised that "truth is stranger than fiction."

Chapter 15

Stormy Disasters

The fishermen know that the sea is dangerous and the storm terrible, but they
have never found these dangers sufficient reason for remaining ashore.
—Vincent Van Gogh

August 2, 1934. The colossal storm system careened across the entire
Great Lakes area. From Duluth, Minnesota, across to Buffalo, New York,
anything or anyone in the path of this monster could not stand. National
papers reported, "Using every trick in their repertoire—hail, cloudburst,
lightning, floods, tornados, and subhurricanes—storms ravaged the Great
Lake states and the Atlantic seaboard. Towns were isolated, bridges were
swept away, crops leveled, automobiles stalled, boats wrecked, and houses
were knocked over." All in all, eleven people were killed and over $1 million
in damage was reported, including railway beds, power line poles and even
the wreck of a vacation steamer in Michigan.

In a storm of this magnitude, with winds reaching one hundred miles per
hour on Lake Erie, the most vulnerable location by most opinions would
be on an island, completely exposed to the elements. During the storm of
1934, South Bass Island, in particular Put-in-Bay, suffered the most damage.
Houses and building were completely demolished. Trees by the dozens lay
like fallen soldiers across the island. Power lines were tangled in branches
or lying on the ground with the trees. The huge boat docks and any boats
anchored to them were swept away with the wind and the waves. The
physical damage was terrible, but perhaps more horrifying was the fact that

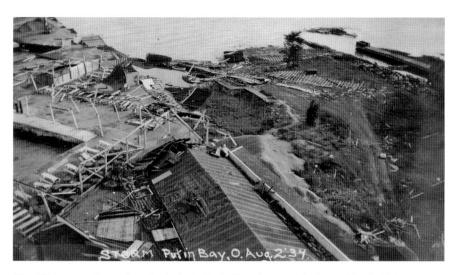

The 1934 storm aftermath at the docks in Put-in-Bay. *Courtesy of the Ottawa Historical Museum.*

without transportation or phone lines, the island was entirely cut off from the rest of the world.

In the fall months, starting in late October, islanders are very alert of potential storms. The winds across the lake shift direction, with a wind system coming down from Canada. Frequently, storms produced this time of year are known as "November's Witch." In November 1913, the deadliest "witch" ever on the Great Lakes raged for four days. The Great Lakes White Hurricane was a product of three storm systems, one being a fierce cold front from Canada. The storm was responsible for killing 250 people and destroying thirteen ships. Locals on the islands hunkered down as they watched twenty-five-foot waves crash on the rocky shores. When the storm was through, cities, islands and small villages along all five Great Lakes were cut off from communications, food supply and news about the storm for several days.

The remoteness during a Lake Erie storm, whether a summer whopper or a winter blast, is what sets the islands apart from the rest of Ohio. There is no place to escape once caught in the storm. And many times in the past, once the storm was over, there was no immediate help available. Communication with the mainland was often lost for hours if not days at a time. Islanders had to learn to rely on one another and adapt to some nontraditional methods of dealing with weather disasters that, over the years, have been abundant and fierce.

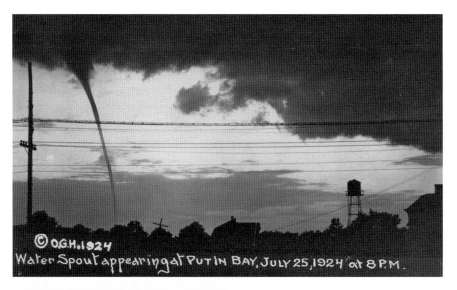

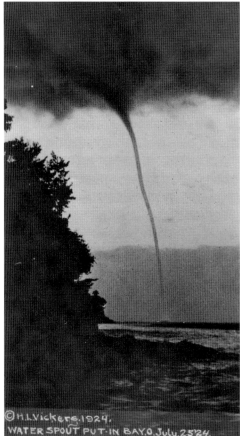

Above: A waterspout appearing near Put-in-Bay, 1924. *Courtesy of the Ottawa Historical Museum.*

Left: A closer view of the waterspout in 1924. *Courtesy of the Ottawa Historical Museum.*

ICE

In the minds of the many Ohioans who do not live near the islands, it seems as though only two seasons must exist "out there on those islands." One is the blue skies, sandy beaches and warm, sunny days of summer. The other? Well, that picture resembles a frigid tundra, with the islands frozen in place due to the thick ice of Lake Erie. The sunshiny day picture is easy to understand, as most non-islanders have only visited the islands in the summer season. As for the ice fields, this image is often conjured as it is the most fascinating idea while thinking of the lake during the long, cold winter months. Although there are definitely more than two seasons on the islands, the icy one does exist for a portion of the year when conditions are right.

One of the first island explorers, Tilly Buttrick, decided to cross the ice in order to explore the islands in 1820. No one knows why he chose early March, when the lake was frozen, as Tilly lived in Sandusky year-round. Perhaps he thought the ice travel would be faster. Anyhow, Tilly and his companions began the trek across the frozen bay area, dragging a canoe as they went. About halfway across the bay, a horrible crack was heard, and Tilly and one other man went crashing through the ice into water well above their heads. The other explorers threw in the canoe, and the two were pulled to the safety of thicker ice. The men made their way to Cedar Point, which was not an amusement park at the time. While resting there, a winter gale blew across the lake, bringing in and then freezing the open water. The men were now trapped and used the canoe as shelter through the night. They did not make it to any of the islands on that chilly adventure.

Sometimes tales of traveling the ice are in the reverse. That is, sometimes people on the islands felt a need to come to the mainland. Such was the tale of Heinie Elfers and the Kelley's Island Transportation Company in February 1912. When the lake was safely frozen over, Heinie offered transport across the lake via his large sleigh that was pulled by two horses named Dick and Billy. One cold afternoon, Heinie was commissioned to transport supplies into Marblehead. With his local island friend, Charlie Himmelein, the men, horses and loaded-down sleigh began the journey across the lake. As they passed Johnson Island, the ice gave way. The horses and sled all fell through the ice. Heinie and Himmelein worked to pull the horses free, but the weight of the beasts proved to be too heavy. Both horses died in the accident.

One of the most heart-wrenching tales on ice occurred in the winter of 1940. Dr. George Edam, thirty-three; his wife, Loretta, twenty-nine; and their two children, both under age five, perished in a horrific accident.

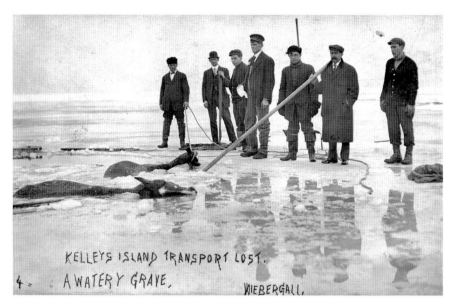

Kelley's Island transport horses after a fall through the ice. *Courtesy of the Sandusky Library Follett House Museum Archives.*

A small boat on the icy waters of Lake Erie. *Courtesy of the Sandusky Library Follett House Museum Archives.*

While driving across the "ice bridge" between the islands, their automobile broke through the ice. The ice bridge had been used for years during other winters. In fact, in 1936 it was recorded that more than 180 cars crossed from Marblehead to Kelley's Island in that manner. In 1940, a car trip across the lake and around the islands most likely seemed like a great adventure. However, that was not the case as the Edam family made their journey between Put-in-Bay and Middle Bass Island. A witness said she watched as the car seemed to disappear from the road. When she realized what had happened, she immediately contacted authorities. But it was too late. The next day, the car with the two children inside was pulled from under thirty feet of water. The parents were found floating under the ice.

The ice, with its fascinating beauty and mystery, can be a deadly backyard. Islanders are well aware of this and respect the ice and lake no matter how safe it seems.

MAROONED

Although often it is thought people may not want to be on an island in a violent Lake Erie storm, some find it's the only place to weather out an angry sea. For instance, an early snowstorm in October 1939 showed up for the annual hunting competition held on Pelee Island. For the next two days, eight hundred hunters were stranded on the island while the gale-force winds and snow whipped about the open waters.

Oftentimes, ships in search of shelter from a storm make their way to the islands as a refuge area. The lake, with its angry waves, shoves the ships onto a nearby island, marooning them for days, even weeks, even after the storm has passed. Such was the case for the passenger steamer *State of Ohio*.

On September 29, 1909, the proud steamer *State of Ohio* puffed through the western basin of Lake Erie. Loaded down with passengers to Toledo, the voyage was a routine trip for the old steamer. As Captain McLaughlin steered the ship out of the course of the islands, he realized that the waves had grown to large proportions during the half hour since departure. What he did not realize is that the waves had pulled the steamer in a northward direction. When the vessel slammed a rocky shore, the captain and crew had no warning.

The steamer was aground on Rattlesnake Island. To make matters worse, dark clouds were covering the skies as the waves continued to build in strength.

On board, passengers were beginning to panic. Captain McLaughlin, being of a kind nature, first sought to assist his passengers, making sure none had been physically harmed. The *Plain Dealer* would later report, "There would have been a panic aboard when the grounding occurred but for the captain and crew who gave every assurance that there was no danger. Order was soon restored."

The captain next ordered the engines of *State of Ohio* to be set to full steam. This proved useless. The steamer was not going anywhere anytime soon. The wind and waves continued to add to the distress, sometimes crashing over the decks of the ship.

Meanwhile, the captain and two crewmen made a decision to row across the channel to Put-in-Bay. This, too, proved useless as halfway across, the wind easily picked up and flipped over the small yawl, forcing the men back to Rattlesnake Island. Once back on the steamer, the distress flags were raised from the top deck in hopes that help would soon come along.

Bravely, Commodore Worthington saw the distress signals and took his personal sailing yacht, *Pricilla*, across the way to assist. The passengers were loaded onto the *Pricilla* and taken to Put-in-Bay to wait out the storm for the next couple of days. The captain and some of his crew chose to stay with the stranded ship in hopes that a rescue ship would arrive. For two days they waited, and for two days the high winds and waves prevented help from coming. In fact, many vessels did attempt to reach the *State of Ohio* but turned back only to be stranded at Put-in-Bay through the three-day storm.

The captain and his two crewmen again attempted to row across the channel, and again the tiny vessel was capsized as though it were a toy boat. As the men crawled back into the rowboat, they collapsed in complete exhaustion. But just as all hope was gone, a huge steamer came nosing its way around the tip of Gibraltar Island. Commanded by Captain Dodge, the *Wayward* eased its way to the men. Captain Dodge, who had been on many rescue missions in his years as a mariner, cautiously guided the steamer along the rowboat. His main thought was to not have the *Wayward* crush the tiny boat being tossed about in the waves. Quickly, the endangered men grabbed the extended rescue ropes and were pulled to safety. Two days later, after dozens of attempts, the *State of Ohio* was tugged to Sandusky to be refitted.

The next Christmas, Captain Dodge found a plain envelope in his mailbox. A large amount of money had been collected among the *State of Ohio* crew and sent to him for his bravery. The next year, a medal was given to the captain for his many rescue missions on Lake Erie.

Conclusion

Shooting across the lake from Port Clinton to Put-in-Bay on the Jet Express, a large group of tourists laugh and cheer in delight. The speed of the ferry, the splash of the water as they bounce from wave to wave and the feel of warm wind in the air set the crowd up for an exciting

A night view of Perry's Victory and International Peace Memorial. *Courtesy of the Ottawa Historical Museum.*

adventure. Closer to their destination, the crowd glances at the towering Perry's Monument, a welcoming landmark for any island-goer. Shops, bars and golf carts now can be seen lining the lanes between the trees. The excitement is almost palpable at the ferry docks. Most likely, this will be a trip of a lifetime for this happy crew.

Yet something in this place anchors to a feeling of sadness and tragedy. Perhaps it's the way the water laps and sometimes lashes at the island shores, demonstrating its full control over the area. Maybe it's the way the moonlight rises over the island trees, illuminating the total remoteness of each. Or maybe it's found in the eyes of the old-timers who show a deep respect for what the trials of island life can mean.

Yet even with the hints of danger, Ohio's Lake Erie islands and all their charm also take anchor in the heart of anyone who sets foot on them. As an island saying goes, "I did not know how much I missed the island, until the day I first arrived."

Bibliography

Barr, Henry M. *Lonz of Middle Bass: The Tale of a Man, a Woman, a Building, and an Island*. Berea, OH: H.M. Barr, 1982. (Box 769, Berea 44017)

Canton Repository

Cleveland Plain Dealer

Columbus Dispatch

Connell, Wil, and Pat Connell. *Ohio Lighthouses*. Charleston, SC: Arcadia Publishing, 2011.

Cruiskshank, Nancy. "South Bass Island Lighthouse." Ohio Seagrant Commination FS-079. 1999.

Dodge, Robert J. *Isolated Splendor: Put-in-Bay and South Bass Island*. Hicksville, NY: Exposition Press, 1975.

Downhower, Jerry F. *The Biogeography of the Island Region of Western Lake Erie*. Columbus: Ohio State University Press, 1988.

Ellinger, Esther Parker. *The Southern War Poetry of the Civil War*. New York: B. Franklin, 1970.

Frohman, Charles E. *Put-in-Bay: Its History*. Columbus: Ohio Historical Society, 1971.

Gora, Michael. *Lake Erie Islands: Sketches and Stories of the First Century after the Battle of Lake Erie*. Victoria, BC: Traffford, 2004.

Hatcher, Harlan. *Lake Erie*. Indianapolis, IN: Bobbs-Merrill Company, 1945.

Herdendorf, Charles E., and Ronald L. Stuckey. *Lake Erie and the Erie Islands*. Columbus: Ohio State University, Center for Lake Erie Area Research, 1977.

Hildebrandt, John. "The Man Who Financed the Civil War." *North and South Magazine* 14 (September 2012).

Johnson Estate Winery. "Microclimate and Terroir." johnsonwinery.com/jos_lakeeriemicroclimate.html.

Johnson's Island Preservaton Society. "Confederate Prisoners of War on Johnson's Island, Ohio." www.johnsonsisland.org.

Kelley's Island Histrical Preservation Corporation. www.kihpc.org.

Lighthouse Friends. "South Bass Island, OH." http://www.lighthousefriends.com/light.asp?ID=276.

Martin, Jessie A. *The Beginnings and Tales of the Lake Erie Islands.* N.p.: J.A. Martin, 1990.

Martin, Jessie A., and Charles Edward Martin. *A History and Some Tales of Kelleys Island, Ohio.* Minneapolis, MN: Denison, 1975.

News-Herald, Port Clinton

Norgard, Richard. The Sailing Ship *Success.* www.shipsuccess.com/content/Home.

Ohio Department of Natural Resources. "Lonz Winery/Middle Bass Island Open House." June 24, 2014. ohiodnr.gov/news/post/lonz-winery-middle-bass-island-open-house.

Port Clinton Herald and Republican

Put-in-Bay Gazette

Radford, Neil. "The Convict Ship *Success*: A Very Successful Hoax." Book Collectors' News. January 1, 2005. bookcollectorsbooks.blogspot.com.

Ross, Harry Houghton. *Enchanting Isles of Erie.* N.p., 1949.

Ryall, Lydia Jane. *Sketches and Stories of the Lake Erie Islands.* Perry Centennial edition. Norwalk, OH: American Publishers, 1913.

Sandusky History. sanduskyhistory.blogspot.com.

Sandusky Register

Thorndale, Theresa. *Sketches and Stories of the Lake Erie Islands.* Sandusky, OH: I.F. Mack & Brother, 1898.

Toledo Blade

Wells, John. *The History & Local Post of Rattlesnake Island Lake Erie.* Dublin, OH: BPR Publishers, 2009.

Williams, William. *History of the Firelands Compromising Huron and Erie Counties.* Cleveland, OH: Press of Leader Printing, 1879.

Wright, Larry, and Patricia Wright. *Great Lakes Lighthouses Encyclopedia.* Erin, ON: Boston Mills Press, 2006.

About the Author

Wendy Koile is a full-time English instructor at Zane State College. She holds master's degree in teaching. Wendy has enjoyed Lake Erie vacations her entire life and continues the tradition with her own daughter. This is Wendy's third book with The History Press.

Visit us at
www.historypress.net
..

This title is also available as an e-book